NEW YORK

BY NEIGHBORHOOD

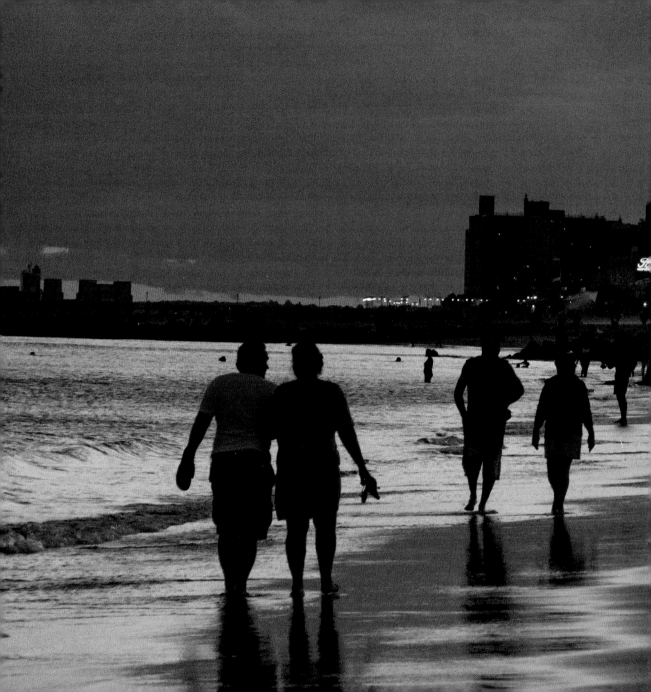

UNIVERSE

NEW YORK

BY NEIGHBORHOOD

ANDREW GARN

page 1:
Empire State Building set against a winter dusk sky from Sunnyside, Queens

pages 2-3:
Nightfall on the beach in Coney Island, Parachute Jump in background

INTRODUCTION

My initial attempt at documenting New York City neighborhoods began as a school project at Stuyvesant High School in the 1970s. On Sundays, my father and I meandered throughout the city in our 1969 Oldsmobile F-85, from the Bronx to Staten Island; the West Village to Flushing, Queens. When we saw an interesting streetscape, he would pull over and I would jump out, shooting a couple of exposures of 35mm Tri-X film in my Nikomat FTN. Later at home, I would develop the film in the bathroom and then make 5x7" prints with the Bogen enlarger balanced on the toilet, developer and fixer trays lined up in the bathtub. When the prints were dry, I placed them into an album and hand wrote what architectural history and sense of place that the streets portrayed to a teenager.

There are certainly more traditionally beautiful cities—Paris, London, Rome and St. Petersburg come to mind—but NYC has alternate beauties like no other city: diversity, constant excitement, spectacle and the everyday parade of humanity, "the healthy ballet of the sidewalk," as Jane Jacobs termed it.

When I scoured the streets to uncover the character of each neighborhood for this book, often walking 40 to 50 miles a week, I rediscovered that New York City is BIG. Even as a native New Yorker, I was shocked when embarking on this project at the sheer vastness of the city. The island of Manhattan has a 29.8-mile perimeter; it's 31.4 miles from Bayside, Queens, to Coney Island, Brooklyn; and Staten Island has a circumference of more than 45 miles. Each city mile measures approximately 20 blocks, and each block is a microcosm unto itself; documenting the city's neighborhoods can be overwhelming. I found many people who were happy to stay within the familiar confines of their neighborhoods, spending most of their lives within a ten-block radius of their apartments, leaving only to travel to work via subway.

There is a worn-out refrain, to the point of cliché, that the streetscape of today's New York City is an endless stream of coffee chains, drug store conglomerates and soulless bank behemoths. However, once the intrepid explorer ventures slightly further afield, one uncovers a more authentic New York. Flushing and Jackson Heights are packed with thriving first-generation immigrant businesses. Fourth-generation shops still anchor neighborhoods like Arthur Avenue in the Bronx. Greenwich Village retains its dozens of restaurants and jazz and folk clubs from the beatnik days. One only needs to jump off the subway way uptown or out in the outer boroughs to see that New York is supremely heterogeneous; according to the Endangered Language Alliance, over 800 languages are spoken here.

The subway, while existing as the economic backbone of the city by transporting workers to their jobs, is also the connective tissue that makes the city accessible to everyone. But few people take advantage of the great mosaic (as former mayor David Dinkins called it), the glistening city, because really, who has the time?

Rain glistening streets reflect the glowing storefronts on the "elbow" of Doyer Street in Chinatown

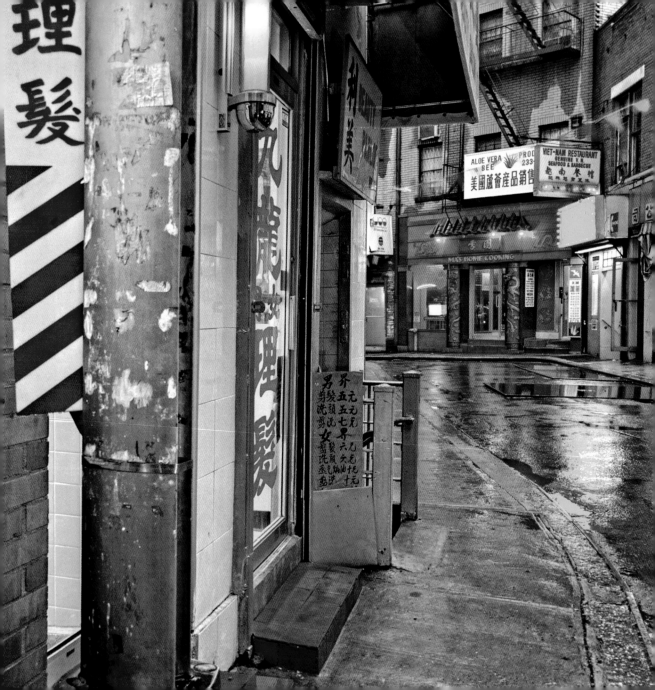

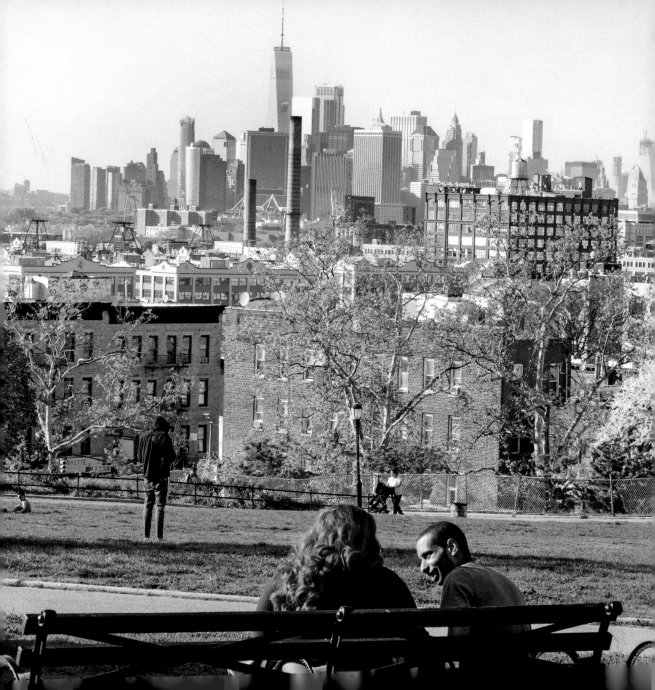

[BROOKLYN]

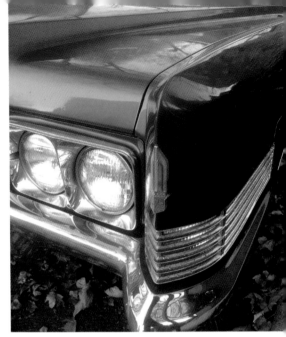
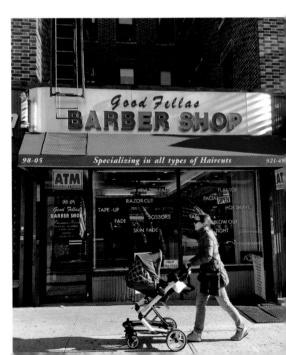

BAY RIDGE

Moviegoers celebrate this South Brooklyn neighborhood as the home turf of disco luminary Tony Manero in *Saturday Night Fever*, whose story was based on a real discotheque in Bay Ridge. Today, the neighborhood maintains its safe and quiet reputation with streets lined with free-standing homes, bow-fronted row houses and squat, prewar apartment buildings. The avenues offer views of the soaring and elegant Verrazano-Narrows Bridge, a gateway to New York Harbor and once the world's longest suspension bridge.

Planned in the late 1950s, to join Staten Island to the rest of New York, the site of the bridge and its ramps and approaches necessitated slicing through Bay Ridge. There was strong community opposition over concerns of increased traffic and the condemnation of properties. Despite the resistance, the all-powerful Robert Moses (then chairman of the Triborough Bridge and Tunnel Authority and Parks Commissioner), forced the project through. Ultimately 7,000 residents were pushed out, many buildings along Fort Hamilton Parkway were demolished and owners paid the bare minimum market price. By 1964, the bridge opened to traffic, bringing thousands of vehicles through the neighborhood every day.

The history of Bay Ridge extends back to 1652, when the Dutch West India Company purchased the land from the Nyack Indians. The Dutch called it Yellow Hook for the color of the soil found there, but in 1853, because of the yellow-fever epidemic of 1848–1849, the name was changed to Bay Ridge, because locals feared that the old name would be associated with the disease.

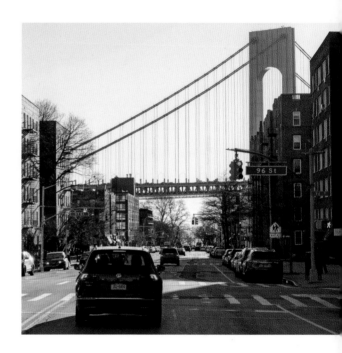

Development of housing picked up in the late 1800s with a stream of Scandinavians, Irish and Italians. More recently there have been Chinese, Russian, Egyptian, Syrian, Greek, Lebanese, and Jordanian immigrants. The diverse population enjoys ocean breezes, good public schools, excellent housing, and myriad food options. The commute into Manhattan, sometimes over an hour each way, has kept rents reasonable by NYC standards.

BROOKLYN

BEDFORD-STUYVESANT

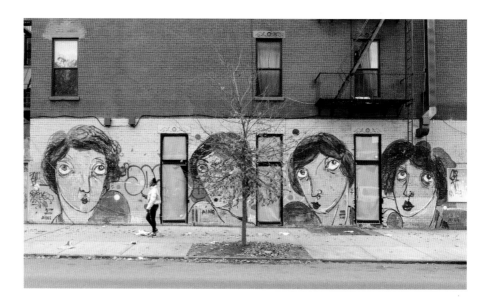

Bedford-Stuyvesant, known popularly as *Bed-Stuy,* is recognized for its long, wide streets, shaded by leafy trees and beautiful, stately homes. Entire blocks and specific homes, (especially in the area called Stuyvesant Heights), have been landmarked by the city because of their architectural significance. The assemblage of mostly intact, pre-1900 Victorian structures might be the largest in the country. Strolling the sidewalks will offer a pedestrian a visual encyclopedia of architectural detailing, including ornate cornices, carved heads, quoins, arches, brackets, finials, flutings and friezes. With its fine homes, space and fresh air, Bed-Stuy has been a stable, African American enclave since the 1930s, attracting many who left the crowded tenements of Harlem. Today, as neighboring areas like Fort Greene and Bushwick have become more expensive and developed, Bed-Stuy is experiencing gentrification and displacement pressures, as home values have tripled over the past decade. First settled in 1662, and named by 1667, the town of Bedford was formally purchased from the Canarsee Indians by the Dutch in 1670. The price was "100 Guilders Seawant [wampum], Half a tun of strong beer, 2 half tuns of good beer, 3 guns, long barrels, with each a pound of powder, and lead proportionable–2 bars to a gun–4 match coates."

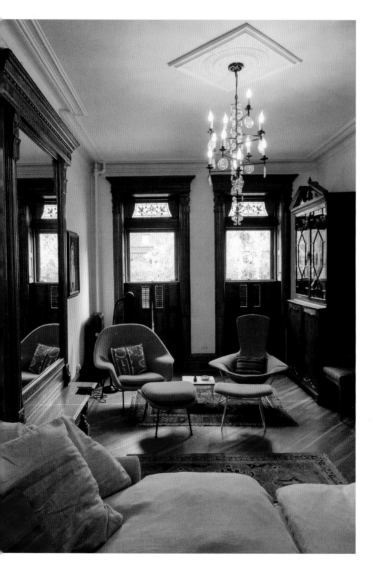

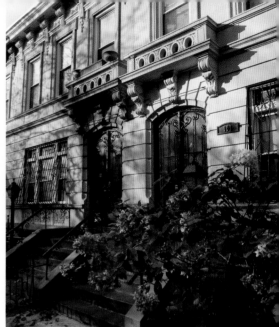

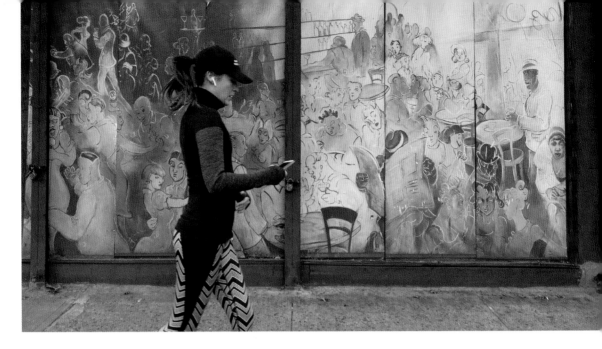

Previous spread:
page 12: Alan Aine mural (2018), Patchen Avenue
page 13 (clockwise from left): Brownstone living room, with original wood-work; limestone townhouses, Stuyvesant Heights; Dahlander Townhouse, copper turret details, Stuyvesant Heights
This spread:
opposite (top to bottom): Jogger walks past nightclub mural; roman brick detail, Stuyvesant Heights
this page (top to bottom): Matching limestone townhouse entries, Stuyvesant Avenue; Pink Ghost bike memorial

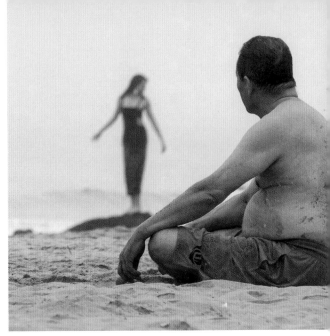

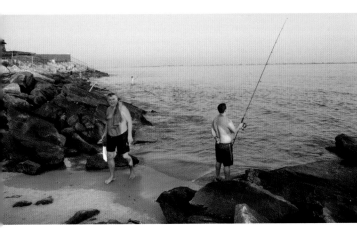

BRIGHTON BEACH

While the beach and boardwalk in Brighton is a bit less hectic than neighboring Coney Island, it offers the very same ocean views and adds al fresco dining on the boardwalk overlooking a constant parade of humanity. Subsequent to the Civil War, the entrepreneur William A. Engeman began methodically purchasing the two-acre plots east of Coney Island that was then called Middle Division. Over several years he was able to assemble a few hundred acres of oceanfront property for $20,000, naming it Brighton Beach, in honor of the famous English beach resort. Historically, Brighton Beach has never been as celebrated for pageantry and extravaganza as Coney Island, but Engeman and his son were able to establish a solid middle-class resort area, building hotels, a pier, a music hall (that was the summer home to the Metropolitan Opera), bathhouses, an aquarium and the Brighton Beach Race Course for horse racing. By the early 1900s, many Jews from the Lower East Side and other parts of Brooklyn began putting down roots in Brighton. The original housing stock was small wooden bungalows, many of which still exist on side streets, whereas nearer the ocean, new apartment buildings rose in the 1920s and '30s. The neighborhood remained respectable, if not slightly neglected after WWII and through the mid '70s. When "white flight" started to vacate many apartments throughout the city, there was a simultaneous surge in former Soviet citizens settling in Brighton, when emigration laws were relaxed in Russia. It was now referred to as "Little Odessa," for the Ukrainian resort town on the Black Sea. Under the clamorous elevated line runs Brighton Beach Avenue, thronged with Russian restaurants specializing in borscht and pierogies, nightclubs that serve bottles of Russian Vodka frozen in blocks of ice, and rows of fruit and vegetable vendors. In the past few years there has been an uptick in newer immigrants from Middle Asia, including the formerly Soviet 'stans and Uighurs, all bringing their customs and recipes with them, adding to the dining and shopping choices.

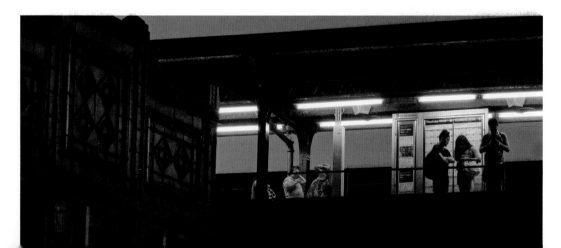

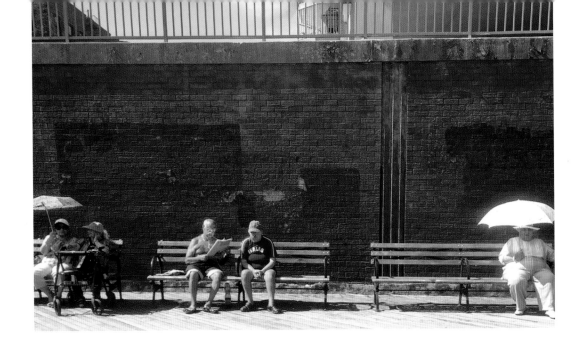

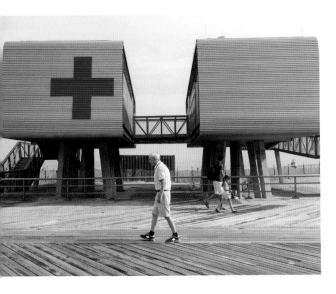

Previos spread:
page 16 (clockwise from upper left): Flirting on the surf; dreaming of a Goddess of the Sea; Tashlikh ceremony, tossing bread into the sea to represent casting away sins of the past, between Rosh Hashanah and on Yom Kippur; fishermen on rock jetties
page 17: Waiting on the elevated platform for a train to the city after a long day at the beach

This spread:
this page (top to bottom): Pensioners relaxing on the Boardwalk; modern elevated restrooms and First Aid Station
opposite (top to bottom): Man tosses treats for the gulls; pedestrian parade in front of Tatiana restaurant

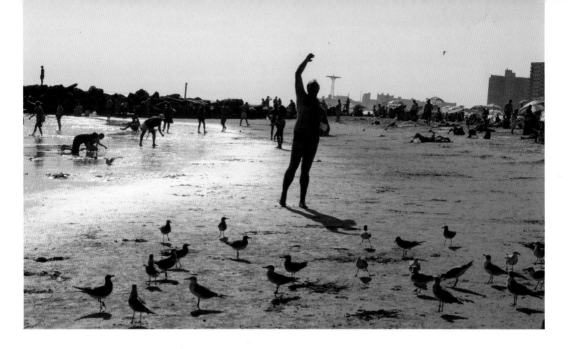

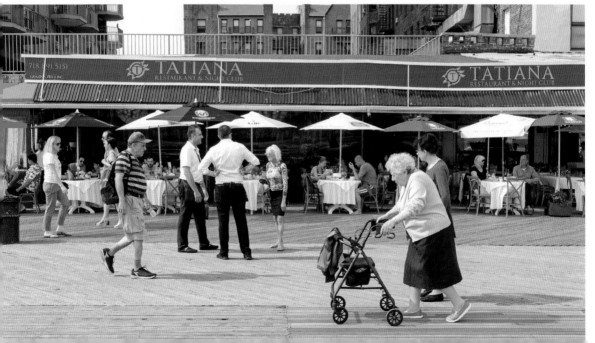

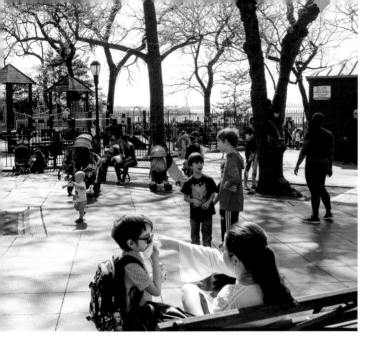

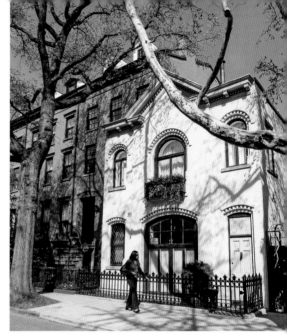

BROOKLYN HEIGHTS

Home to native indigenous groups for centuries, these bluffs overlooking the East River are today called Brooklyn Heights. Ferries began landing at the foot of Fulton Street as early as 1642, delivering goods from the farms of Brooklyn into Manhattan. More regular and reliable ferry crossings began in 1814 with the advent of Robert Fulton's steam ferry. As the rate of commerce increased, the existing farmland was rapidly developed, and by the 1820s farms were laid out into the now standard 25-by-100-foot lots. Growth continued in the Heights throughout the 1800s, as houses became larger and more grandiose for the prosperous merchants who owned the ships that docked below on the East River. With the opening of the first subway station in 1908, the neighborhood began to lose its bucolic feeling, which in turn prompted many wealthy people to move farther afield. The large grand homes, many standing empty, were cut up and turned into apartments and rooming houses. By the Depression, most homes had deteriorated into substandard housing for longshoremen who worked the nearby docks and factories. The city determined that parts of the neighborhood were slums. With the guiding force of Robert Moses, blocks were cleared using eminent domain, which forced property owners to sell what were deemed blighted holdings to the state for the public good. In this case the city and Moses created an entry ramp for the Brooklyn Bridge, sections of the Brooklyn Queens Expressway, and concrete high-rises. As a concession to neighborhood associations, who strongly opposed the destruction of buildings and intrusion of highways, an esplanade was built

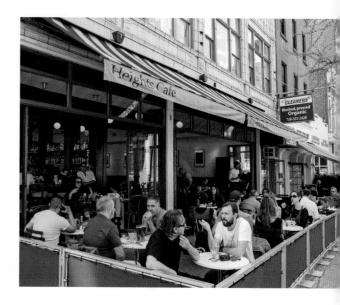

over the expressway affording poetic views of the downtown Manhattan skyline. Unfortunately, it was only after the neighborhood character had been disrupted and carved up that the neighborhood preservations succeeded in having the remaining area declared the first historic district in New York City. In spite of this, the remaining neighborhood is one of the most expensive and exclusive areas in the city, thanks in part to the splendid assortment of late nineteenth-century architecture on peaceful tree-lined streets.

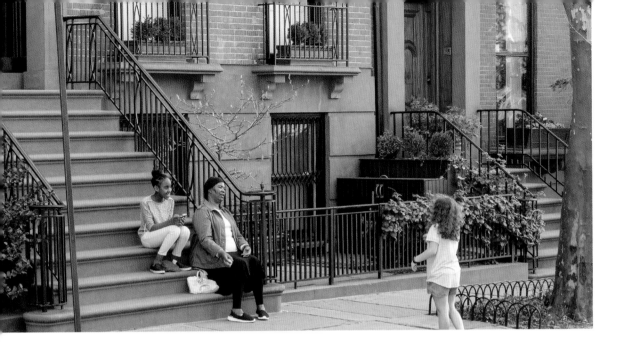

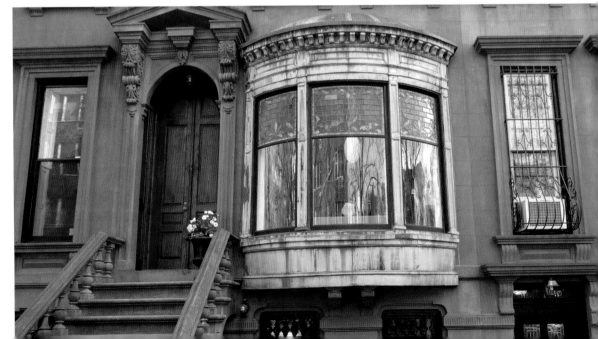

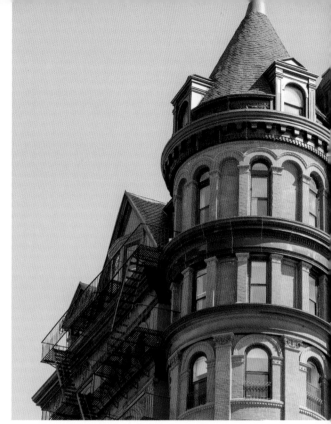

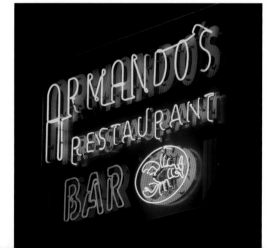

Previous spread:
page 20 (clockwise from upper left): Playground overlooking New York Harbor;
former carriage house converted to home; townhouse gardens off Grace Court
page 21: Heights Café, Montague Street

This spread:
opposite (top to bottom): Chatting and tossing a ball on brownstone stoop;
bowed copper window projection, Grace Court
this page (clockwise from upper left): Walkway from Brooklyn Heights Prome-
nade to Brooklyn Bridge Park; The Arlington, a turreted red brick and terracotta
Romanesque Revival apartment house designed by Montrose Morris, in 1887,
on Montague Street; once a favorite of players from the Brooklyn Dodgers,
Armando's on Montague has recently closed its doors

BROOKLYN

BUSHWICK

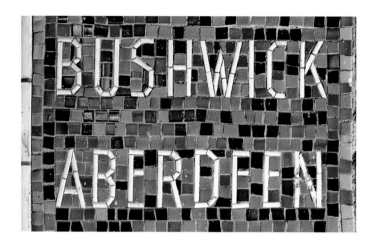

The first development of Bushwick commenced in 1638, when the Dutch West India Company deeded a large parcel of land (which also included parts of Williamsburg and Greenpoint) from the Lenape people. In 1661, Peter Stuyvesant, an agent for DWIC, named it *Boswijck* or "little town in the woods," and began establishing farm plots. It remained in Dutch hands until 1683, when the British took command and united other contiguous towns under the umbrella of Kings County. By the 1800s, Bushwick became a neighborhood of mostly German immigrants. Many came to work in the newly opened breweries and factories that located here because of the proximity to the ample water supply from the Ridgewood reservoirs. The Germans built numerous churches and simple frame houses on the side streets, while mansions for the business barons lined Bushwick Avenue. The area remained a fairly stable mix of industrial and low-rise housing until the 1960s when a combination of "white flight," the city's monetary woes, and heavy looting and arson during the 1977 blackout placed Bushwick into a downward spiral. In the 1970s and '80s there was an influx of new Hispanic immigrants, but many of the weed strewn lots remained, as poverty and crack use prevailed. The neighborhood stayed under the radar until the mid 2000s, when development pressure from Williamsburg to the west brought many artist and hipster types to the relatively (at the time) cheap housing. Today, Bushwick has gone through a renaissance with many of the mansions and townhouses being renovated, along with new residential projects being developed on former factory sites and vacant land. Restaurants and bars are popping up and there are various live music venues in the more industrial areas.

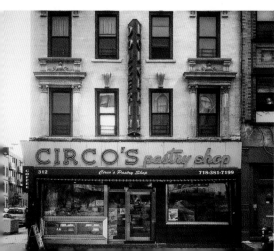

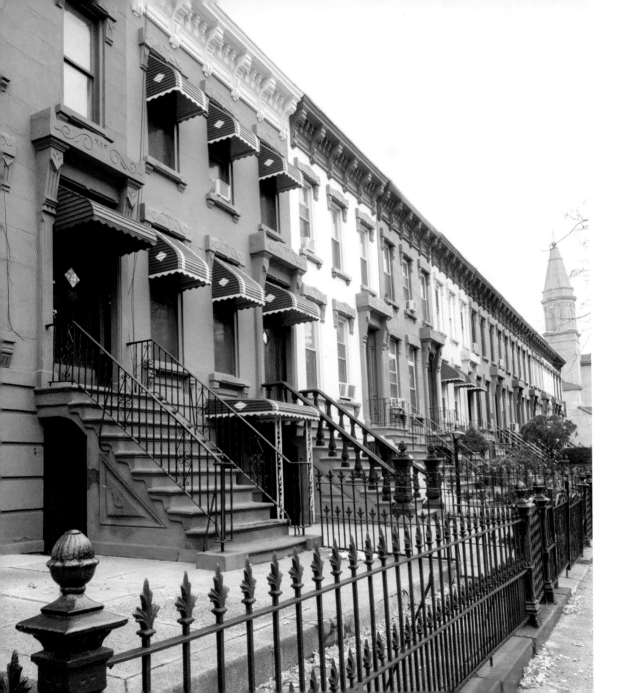

Previous spread:
page 24: Mosaic destination sign for Bushwick Aberdeen station, designed by Square Vickers for the MTA
page 25 (clockwise from top): Myrtle Avenue elevated line at dusk; customized Cadillac Seville; original signage Circo's Pastry Shop

This spread:
opposite: Colorful row houses
this page (left to right): Rooftop pigeon loft near Myrtle Avenue; turquoise 1960 Chevrolet Impala flattop sedan

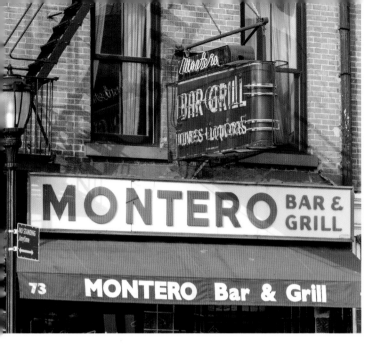

opposite (clockwise from left): Montero, Bar and Grill, Atlantic Avenue, with original neon, once a favorite spot of sailors from the Brooklyn piers; Union Street brownstones with typical front yards; the recently reinvented Long Island Restaurant with original bar and neon, is known for its cocktails and simple American fare

bottom: Pacific Green Gourmet Food on Court Street

COBBLE HILL

Twelve years following the founding of the New Amsterdam settlement in 1624, Dutch settlers purchased 1,000 acres of land from the local Leni Lenapes in the area that is today called Cobble Hill. Naming it Gowanus, these early entrepreneurs proceeded to fill in the swampy land, work the soil for farmland (in many cases using enslaved Africans), and used the Gowanus creek to transport their goods to market. During the Revolutionary War, the British leveled the top of what was called "Cobleshill" (near today's intersection of Atlantic and Court Street), so that it would not offer a vista of their headquarters in Brooklyn Heights. The 1870s brought the development of some of the city's earliest tenement apartment buildings, called the "Warren Place Workingman's Cottages and the Home and Tower Buildings." Designed by William Field and son, the buildings provided interior courtyards, light and air to all the rooms, decorative ironwork and private bathrooms. These handsome red brick buildings, with lacy ironwork still stand today. Presently, Cobble Hill is a quiet, mostly residential quarter of young families bounded to the north by the commercial Atlantic Avenue. Although not as architecturally grand at its neighbors Brooklyn Heights and Fort Greene, the side streets are mostly landmarked, offering a nice sampling of nineteenth-century brownstones and row houses. Smith and Court streets are the low-key commercial thoroughfares that offer restaurants, coffee shops and some older Italian specialty shops, which connect to the days when it was a mostly Italian neighborhood.

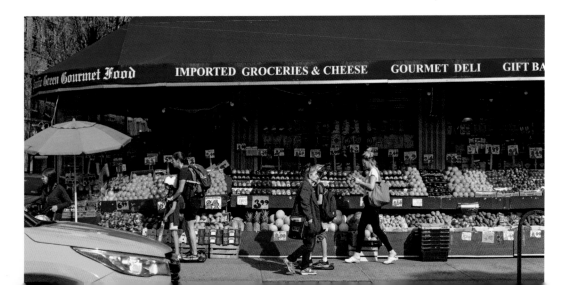

CONEY ISLAND

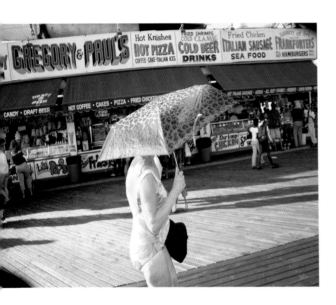

The marvels of aviation, radio and electricity around the turn of the twentieth century coincided with the heyday of Coney Island. 1897 brought George Tiylou's Steeplechase Park (the first of the grand enclosed parks within Coney Island), whose centerpiece was the iconic Parachute Jump, which still stands today as a NYC landmark. Opening soon thereafter were the equally spectacular Dreamland and Luna Park. The later had towers festooned with over one million electric lights, competing with Steeplechase to have the most thrilling rides, eye-popping freak shows, and other crowd-pleasing amusements, like live baby incubators, re-enactments of Noah's Ark, and a diorama of a "Trip to the Moon," with living "moon men" of very short stature who gave out samples of green cheese. At various times, the parks all burned to the ground, but were quickly rebuilt with newer and bigger rides and attractions. The streets around the amusement parks offered something for everyone, including gambling halls, brothels and various flim-flam con men, always looking for opportunities to bilk tourists out of their hard-earned cash. Today, Coney Island is an embodiment of New York's incredible diversity. The city's chaos and the sense of acceptance for outsiders are on full display here, especially during the annual Mermaid Parade, where one finds a rich display of the odd and bizarre. Still looming over Coney Island are the landmarked, century-old Wonder Wheel Ferris wheel and Cyclone rollercoaster. The Cyclone still creaks and moans as it rises and dips through the air, causing mild heart trauma to the more fragile among us. Coney Island was "discovered" in 1609 when Henry Hudson sailed along the highlands of New Jersey near the entrance to New York Bay on his way northward. Crossing the bar at Sandy Hook, he dropped anchor off a small barren strip of land. For two days, he traded with the native Canarsee Indians, exchanging knives, colored cloth and trinkets for food and furs. On the third day, some crewmen went to explore the bay in a rowboat and were attacked by natives traveling in canoes. One crewman named John Coleman lost his life to an arrow. Hudson and the remaining crew left the area and continued on his voyage up the inlet that was to be called the Hudson River. Coney Island remained a barren strip of sand and marshland until the railroad construction boom after the Civil War. Railroad companies were constantly scouring the northeast in search of undeveloped beachfront areas, and Coney Island, located in close proximity to the rest of booming Brooklyn, was a ripe target. The railway conglomerates purchased beachfront

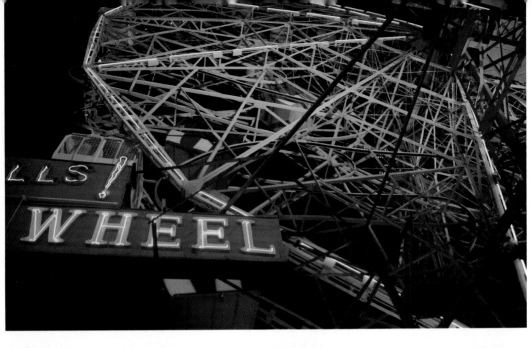

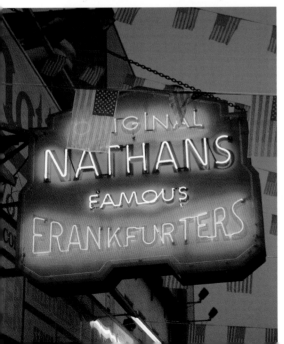

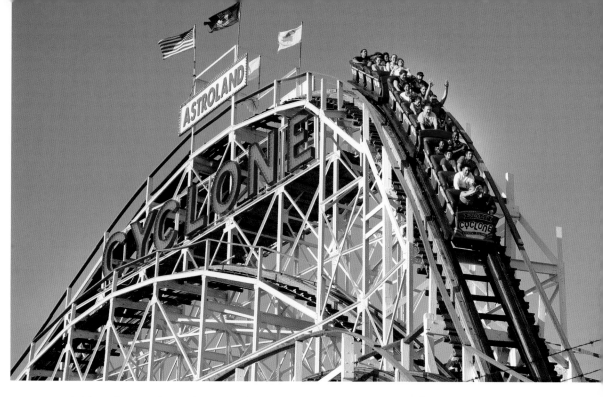

property and rights-of-way to lay track, connecting it to the more populated areas of the city. Major development began soon thereafter. Once a barrier island, Coney Island was accessible only at low tide, because of Coney Island Creek, which separated it from the mainland. As it developed into a summer seaside mecca, the city and private developers began filling in the creek, merging it with the mainland.

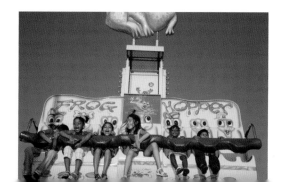

Previous spread:
page 30: Woman with blue-floral one-piece and red-leopard-print umbrella walks along the boardwalk
page 31 (clockwise from top): Built in 1920, at a height of 150 feet, the Wonder Wheel is the last remaining Ferris wheel standing in Coney Island; subway map themed reveler in annual Coney Island Mermaid Parade; opened in 1916 by Polish immigrant Nathan Handwerker, Nathan's Famous is perhaps the most famous hot dog stand in the world

This spread:
opposite: Performers, including founder Dick Zigun (with megaphone), from Coney Island Sideshow
this page (from top to bottom): Built in 1927, the wooden (with steel reinforcement) Cyclone roller coaster reaches a maximum speed of 60 mph on a track length of 2,640 feet, and takes 24 riders at a time on the one -minute, 50-second loop; the modern Frog Hopper offers a gentle vertical lift that is a favorite of young children

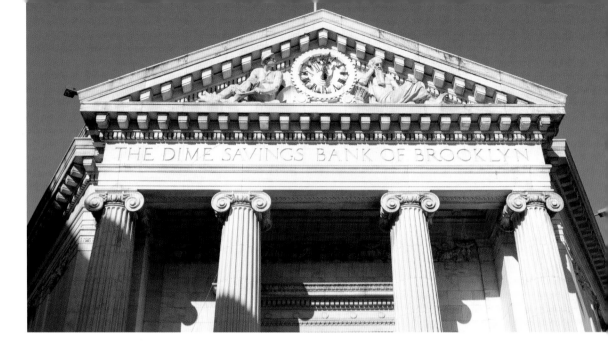

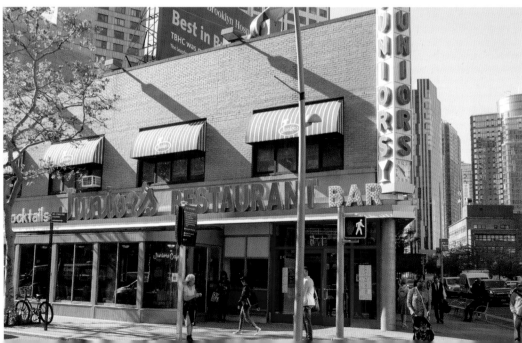

DOWNTOWN BROOKLYN

Possibly no neighborhood in New York City has been more transformed in the past five years than Downtown Brooklyn. As the city's third largest business district (after Lower and Midtown Manhattan), the thickets of mega-towers would be unrecognizable to Brooklynites today, who might remember it as a sort of sleepy shopping area. Downtown Brooklyn was mostly known for chain and discount stores, surrounded by Brooklyn Borough Hall, brooding courthouses, and a sprinkling of schools, including NYU's college of engineering.

The area was occupied by the Lenape Native American tribes until the 1600s, when they were displaced by the appearance of Dutch settlers. The new inhabitants called the area Breuckelen and it remained a quiet, mostly farming quarter until Robert Fulton established steam ferry service to Manhattan in 1814. This fast connection to Lower Manhattan hastened construction of stately homes, and the area became the first suburb of New York City.

In the mid-nineteenth century, Downtown Brooklyn became a cradle for the growing abolitionist movement, with numerous churches and homes becoming safehouses in the Underground Railroad.

The completion of the Brooklyn Bridge in 1883, and the Manhattan Bridge in 1909, made Downtown Brooklyn even more accessible to Manhattan, creating extended building booms, as it began its path to becoming a leading commercial center. In the 1950s, throughout the city, industries ceased operation, dock traffic dried up and stores closed, resulting in a precipitous rise in vacancies and

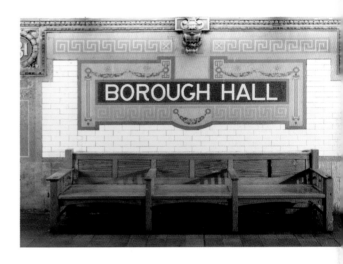

property abandonment in Downtown Brooklyn. This was addressed in the 1960s with large urban renewal projects—the demolition of swathes of older housing, widening of streets like Cadman Plaza West, construction of large apartment blocks, and new state and federal buildings.

The rezoning of Downtown Brooklyn in 2004 brought about much denser and taller building. Now numerous towering structures cluster about, creating a skyline to rival Downtown Manhattan. The tower nearing completion at 9 DeKalb, at 1,066 feet, will surpass the 720-foot Brooklyn Point as the tallest building in New York City outside of Manhattan.

BROOKLYN

DUMBO

Once a thriving manufacturing center known for products such as Brillo soap pads and Arbuckle coffee and sugar, DUMBO (from "Down Under the Manhattan Bridge Overpass"), has morphed from busy industrial district with factories and warehouses, to a desolate no-man's-land occupied by an occasional artist, to a busy residential area on the water's edge with new amenities galore. Its industrial landscape retains a strong visual presence, with quaint cobblestone streets and red brick warehouses, though today the warehouses are converted into condos. One also finds bookstores, St. Ann's Theater for cutting edge stage productions, the Empire Stores warehouse, repurposed with the Time Out food court, Jane's Carousel and Brooklyn Bridge Park. Wedged between two bridges, the twenty-block, once-derelict neighborhood began its turnaround in 1978, when David Walentas started acquiring properties. His first purchase was the iconic Clock Tower building, whose huge four-sided clock can be seen from both bridges. Walentas eventually acquired twelve buildings, containing over eight million square feet of space for about twelve million dollars. As Dumbo has thrived, thanks in part to his foresight and the overall turnaround in New York's economy, today Mr. Walentas is worth over one billion dollars. With trucks passing over the cobblestone streets and the roar of the subway crossing the Manhattan Bridge, Dumbo can be a noisy place. But its spectacular views of the river and the skyline, all perfectly framed by the bridges, seems to overshadow the audio intrusions for most visitors and residents alike.

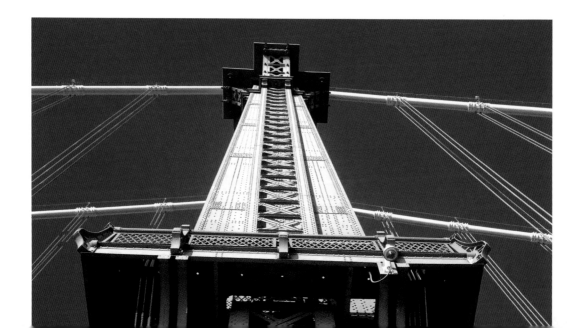

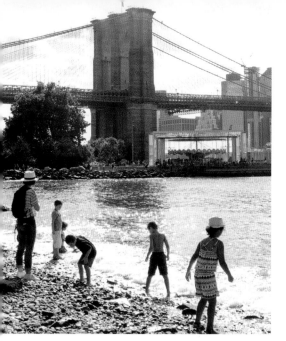

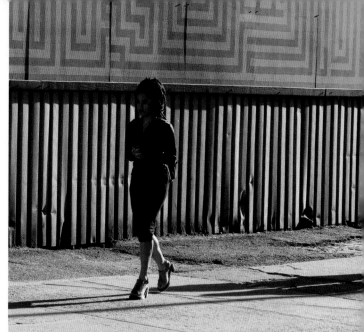

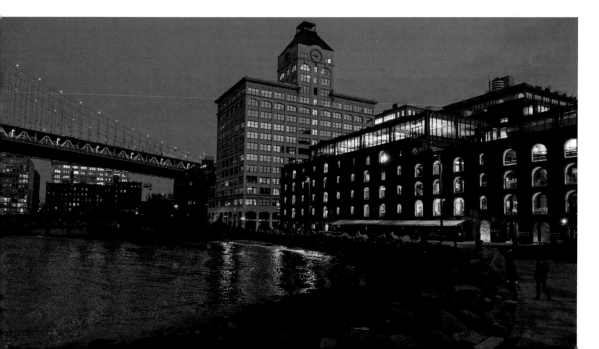

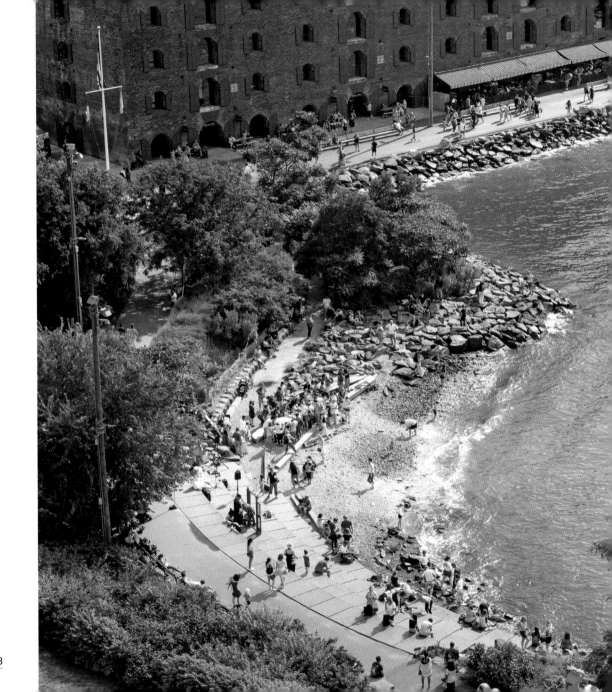

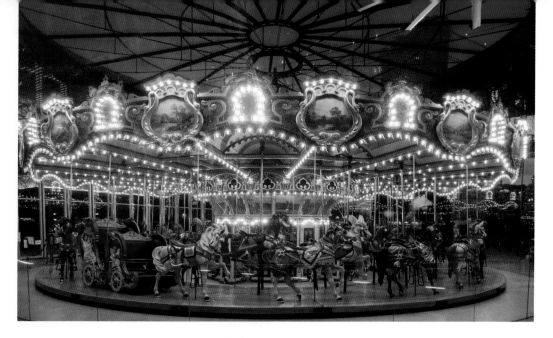

Previous spread:
page 36: Eastern tower of the Manhattan Bridge
page37 (clockwise from upper left): Children skipping stones on Pebble Beach, Brooklyn Bridge in the background; walking under the Manhattan Bridge; from left to right, The Manhattan Bridge, Clocktower Condominiums and Time Out Market at dusk

This spread:
opposite: Summer crowd on Pebble Beach, viewed from Manhattan Bridge
this page (top to bottom): Jane's Carousel at night; Prospect Street double-decker building skybridge

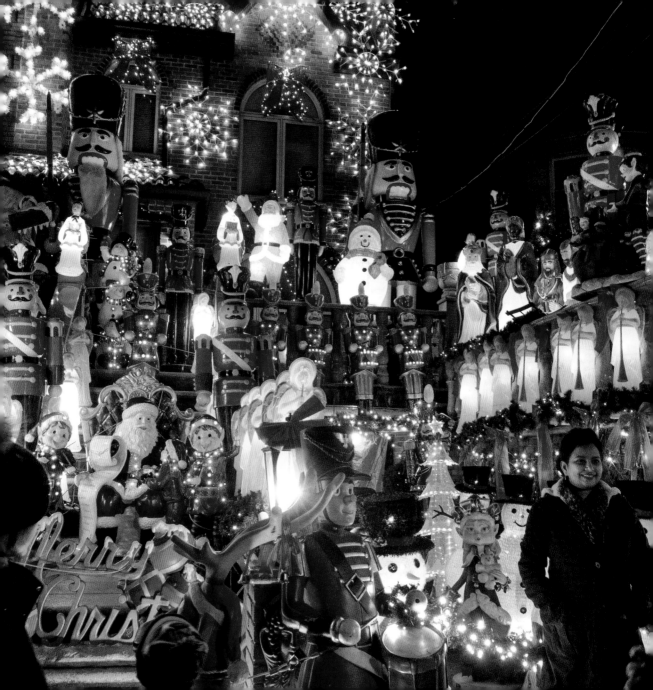

DYKER HEIGHTS

For a majority of the year, Dyker Heights, located in southwestern Brooklyn, is an inconspicuous, suburban-like neighborhood. More than a few of the approximately 50,000, largely Italian-American residents live in exuberant, humongous homes. But come the holiday season, this 1.5-square-mile neighborhood is known as "Dyker Lights." Merely large houses transform into eye-popping showplaces, decked out in a multitude of flashing colored lights, angels, religious figurines, plastic reindeers and Santas. Over the years, as the decorations have become more complex and showy, a sort of competition amongst neighbors has been generated as to who can create the grandest, most spectacular illuminated spectacle that will attract the most gawkers? In fact, the crowds can be so overwhelming on weekends leading up to Christmas that lines of cars and tour buses block the narrow streets and sidewalks are nearly impassable. Over 250 homeowners create various displays, as they have grown more massive, a cottage industry called B & R Christmas Decorators has begun offering a service to help them fabricate the more complicated presentations, which include lighting entire fifty-foot trees and the sides and roofs of houses and chimneys.

FLATBUSH / DITMAS

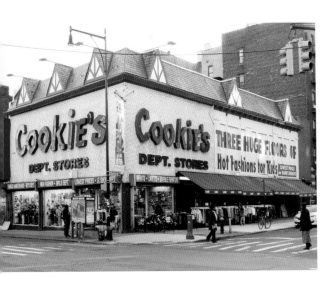

Although farms were existent as early as 1630, Flatbush didn't become an official neighborhood until the middle 1650s, as a Dutch colonial village called "Midwout," or "Middle Woods," referring to its location in the center of Brooklyn. Around the same time, five other towns were incorporated under Dutch rule into what today is part of modern Brooklyn—Bushwick ("Boswijck"), Amersfoort (currently Flatlands), New Uthrect, and Gravesend. By the 1830s, the scattered towns of Brooklyn became more interconnected as stagecoach lines and horse drawn trolleys extended across the borough.

Flatbush was one of the few New York neighborhoods that got its water from underground springs, because of its low elevation. The water source was viable until the 1890s, when neighborhood density increased and discharge from privies and sewer lines began seeping down into the underground springs.

The Ditmas Park section, sitting within Flatbush proper was built on former Ditmas family land by the developer Lewis H. Pounds in the early 1900s. The collection of stately homes, many surrounded by large welcoming porches and expansive leafy trees, incorporate numerous architectural styles, including Queen Anne, Victorian, Colonial Revival, Tudor and Arts and Crafts.

A few blocks from Ditmas Park is the main thoroughfare, Flatbush Avenue, a frenetic retail boulevard with masses of shops catering to the Caribbean and African communities. Private mini vans buzz by, drivers constantly honking horns to attract customers, offering to shuttle them back and forth for a dollar a ride.

Erasmus High School sits in the middle of Flatbush and is renowned for its long list of famous alumni including Beverly Sills, Neil Diamond, Barbara Streisand and Mickey Spillane. Built in 1929, as one of the five original Loews "wonder theaters," the newly renovated Kings Brooklyn Theater anchors the southern part of Flatbush and offers concerts and performances in its wonderfully ornate interior.

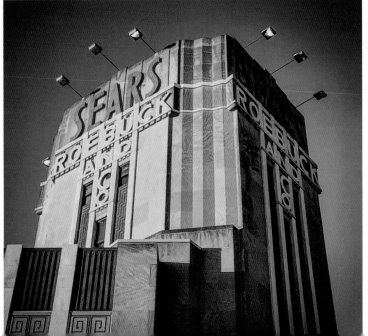

Previous spread:
page 42: Cookie's Department Store with three huge floors of Hot Fashions!
page43 (clockwise from upper left): Weathervane on turret; turreted tower with open viewing; Art Deco tower of Sears, Roebuck store designed by Nimmons, Carr and Wright, opened in 1932 with remarks by Eleanor Roosevelt, who made the very first purchase; owl detail, Erasmus Hall High School

This spread:
opposite: The "Japanese House" on Buckingham Road, completed in 1903, was designed by the firm of Kirby, Petit and Gree
this page (left to right): The Loew's Kings Theater opened in 1929 as one of the five Loew's "Wonder Theaters" in NYC; another private home in land-marked Prospect Park South section

Next spread:
46-47: A mammoth oak stands over a large corner mansion on Albemarle Road

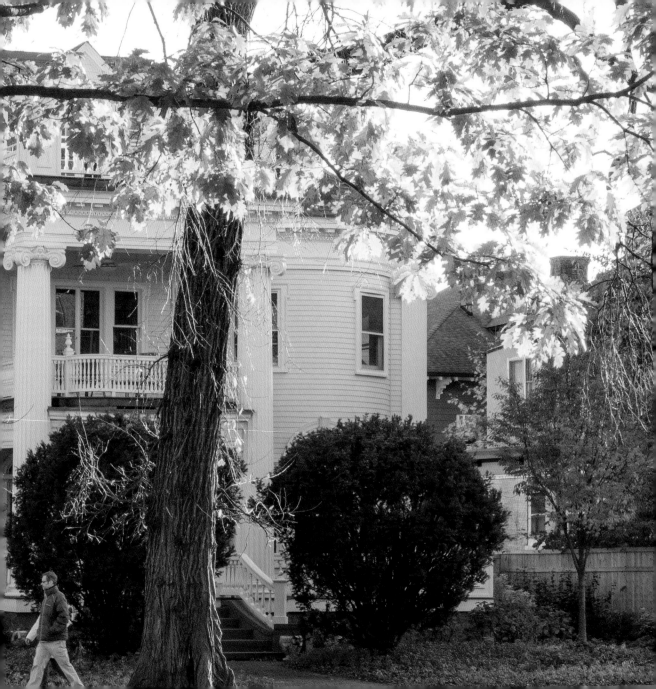

FORT GREENE

Named after the Revolutionary War–era fort built in 1776, under the guidance of General Nathanael Greene, Fort Greene is also home to Brooklyn's first park, originally named Washington Park. The 30-acre green space was redesigned in 1864 by Olmstead and Vaux, and features as its centerpiece the 1908 McKim, Mead & White conceived Prison Ship Martyrs Monument and crypt. The memorial honors the more than 11,000 American soldiers and private citizens who were held prisoner and died of malnutrition or disease, from 1776 to 1783, aboard decommissioned British ships anchored in nearby Wallabout Harbor. The park's surrounding neighborhood developed after the park redesign, with extravagant Italianate- and Eastlake-style brownstones, which rival the townhouses of Brooklyn Heights in their splendor. Nearby Fulton Street is lined with restaurants, bars, clothing shops and bookstores. A landmark for the neighborhood has always been the Williamsburg Savings Bank building on Flatbush Avenue, which was the tallest structure in all of Brooklyn for 80 years until recently as mega development has taken over downtown Brooklyn. The neighborhood is recognized as a cultural center as home to the Brooklyn Academy of Music's various venues for theater, dance and performance. Fort Greene is also close to the underground transportation hub of Atlantic Avenue–Barclays Center station, which accommodates about half of the city's subway lines and the Long Island Railroad.

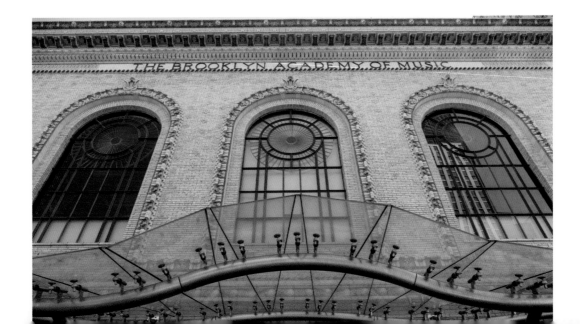

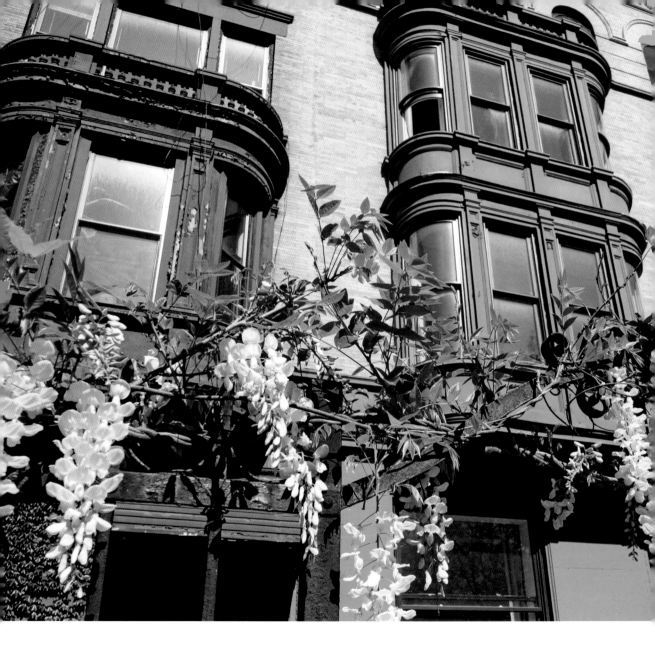

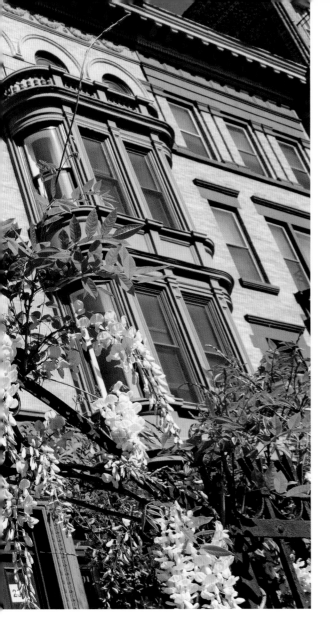

Previous spread:
page 48 (clockwise from left): The Prison Ship Martyrs Monument stands in the center of Fort Greene Park—buit in 1908 to memorialize the 11,000 who died in inhumane conditions on British Prison ships during the Revolutionary War; looking through the Apple store on Flatbush Avenue into the Williamsburgh Savings Bank tower; detail of Brooklyn Masonic Hall, designed by Lord and Monroe in 1907
page 49: The glass canopy addition to the Brooklyn Academy of Music designed by Hugh Hardy in 2008

This spread:
White Wisteria blooms in front of a row of apartment buildings on Clinton Ave; detail from exterior facade of the Willimaburg Savings Bank tower

Follwing spread:
pages 52-53: Row of well preserved Italianate brownstones off Fort Greene Park

BROOKLYN

GOWANUS

Today's Gowanus neighborhood centers around the eponymous 1.8-mile-long canal, which was originally a creek and site of the first settlement of Dutch farmers in Brooklyn. The Dutch were quite knowledgeable about using water-soaked lands to their advantage, utilizing the surrounding ponds in the low-lying swampland to power their gristmills. Gowanus Heights (today's Park Slope) was very strategic during the Revolutionary War, as soldiers could easily view the British ships in New York Bay. The creek was dredged in the 1860s to create a deeper shipping canal, which brought heavy manufacturing. Over the decades, pollution levels surged, with increased ship traffic, and chemical and sewage dumping directly into the water. The canal was declared a Superfund cleanup site in 2010, and is the midst of a ten-year federal clean up. Currently, a new sewage treatment plant is being built by the city, and many of the old manufacturing sites are being cleaned of poisonous soil, capped and covered with clean earth for new residential and retail development. In spite of the cleanup, the past ten years have brought a bounty of new restaurants, a mammoth Whole Foods and a few large apartment complexes. Today, the waterway is getting cleaner and can offer views of both shimmering rainbow-hued oil slicks and an occasional great blue heron.

opposite: Old pickup truck at the Green Building, Union Street
this page (clockwise from top): Third Street Bridge over Gowanus Canal, downtown Brooklyn in background; wintry night on Bond Street; NYC Dept of Sanitation solid waste transfer station

Next spread:
page 56: Stansteel asphalt plant under the Brooklyn–Queens Expressway
page 57 (clockwise from top): Fourth Avenue, now in the midst of massive new apartment building boom; a bare winter tree at night; new apartment building on former brownfield site, directly on the Gowanus Canal

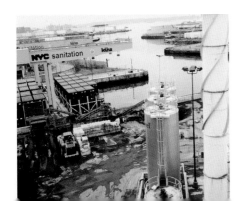

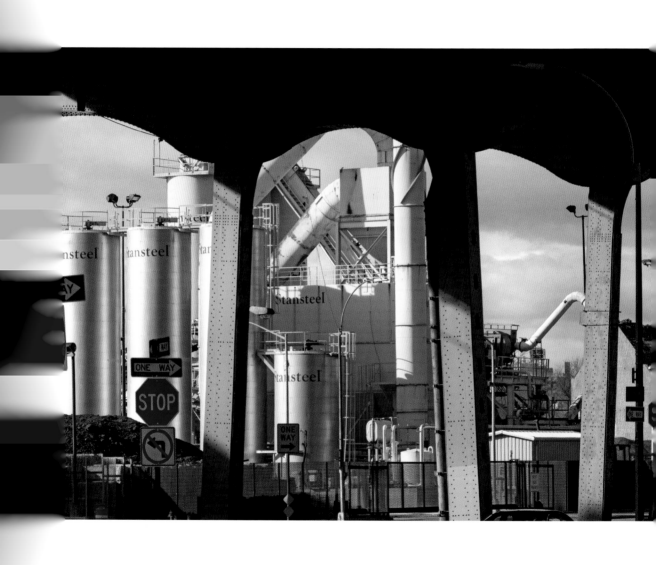

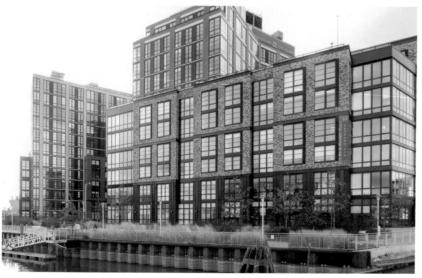

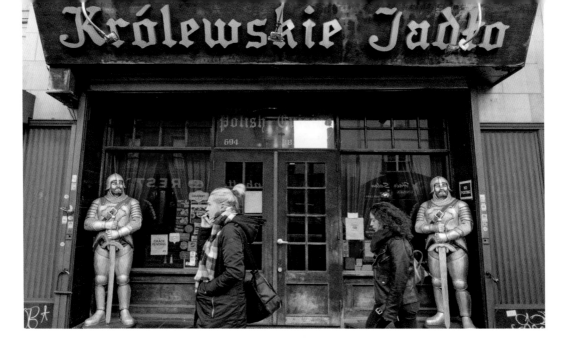

GREENPOINT

Formerly part of the Dutch settlement of Boswijck (Bushwick), Greenpoint was named for its dense tree growth. Mostly a farming community until the influx of Northern Europeans in the mid-1800s, these immigrants brought the knowledge of various manufacturing traditions (known as the "black arts"), including glass and pottery making, printmaking, refining oil and the forging of cast iron. As Greenpoint grew, so did its oil refineries and ship building operations. Newtown Creek was the home of Astral Oil, which refined kerosene used in lamps. The founder, Charles Pratt, was one of the pioneers of using petroleum instead of whale oil for fuels. The use of petroleum products probably saved whales from being hunted to extinction for their oil. Astral, Texaco, Standard Oil, and Exxon-Mobil, all left a legacy of pollution and eventually reached an agreement

with the EPA for site remediation. Newtown Creek continues to serve industry, lined with scrap yards and gas tanks, but it is getting cleaner, as evidenced by occasional wading herons and egrets. Polish, Russian and Italian people began settling in Greenpoint in the 1880s. Many Poles remain, along with a plethora of Polish butchers, food shops, bookstores and restaurants. In spite of recent development along the reclaimed East River waterfront, Greenpoint is still referred to as "Little Poland." Once separated from the rest of Brooklyn and Queens by swamps, the easiest way to access Greenpoint was usually by boat. Today, Greenpoint still has a sense of being removed from the city because there is no direct subway line. It retains a perception of being trapped in time, with much quieter streets than Williamsburg to the south, and Long Island City across Newtown Creek.

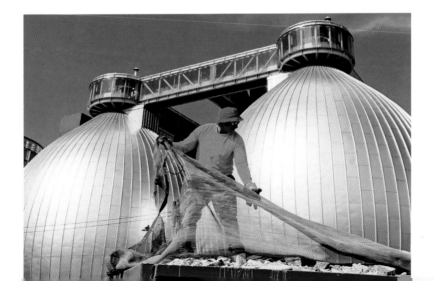

BROOKLYN

GREEN-WOOD CEMETERY

above: The Richard Upjohn–designed Gothic brownstone entry portal is also home to a
large flock of noisy monk parakeets that live there year round
opposite: Assorted statuary and monuments

Incorporated in 1838, Green-Wood Cemetery offers 478 acres of pathways set among manicured hills, specimen trees, statuary, and mausoleums, all situated on a promontory overlooking New York Harbor. Besides providing a place for eternal rest, the cemetery is a spectacular setting for walking, quiet introspection or bird watching. Once known as Battle Hill, as the highest point in Brooklyn, Green-Wood is now the final resting place for over 600,000 people. Envisioned and developed by Henry Evelyn Pierpont as a more bucolic burial spot than the common churchyard, in the beginning Green-Wood had trouble attracting "guests." When the family of DeWitt Clinton (builder of the Erie Canal) arranged for his burial there in 1844, Green-Wood's fortunes changed. It became not only

a popular place to be interred, but also a fine venue for a carriage ride or Sunday stroll, attracting over half a million visitors annually, second only to Niagara Falls as a national tourist site. Its popularity was thought to bring attention to city planners of the need for parks in fast growing metropolises, which in turn influenced the building of Central and Prospect parks. Even today, the cemetery is a fine place for art installations and bird watching, and offers numerous guided tours, which are especially well attended around Halloween. The architect of Trinity Church, Richard Upjohn, designed the entry arches in the Gothic Revival style. These arches have become home to dozens of monk parakeets, which are generally left alone to nest because it is thought that they keep away pigeons.

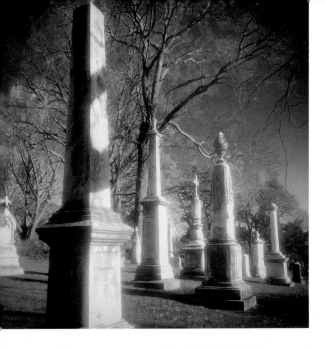

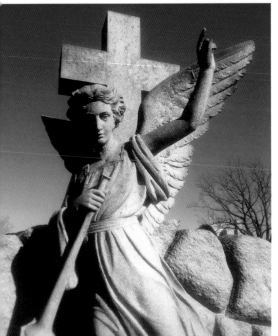

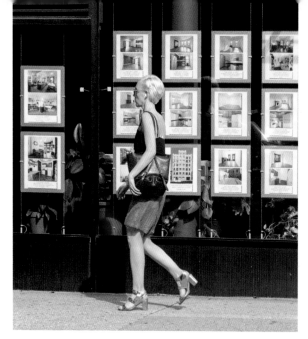

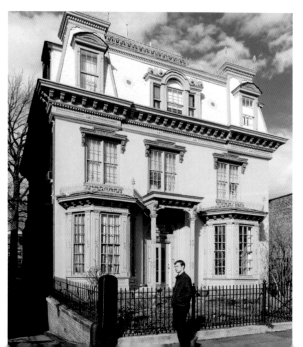

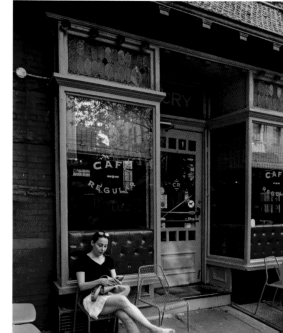

PARK SLOPE

Recognized today for its rows of elegant Queen Anne, Romanesque and Victorian brownstones and sidewalks brimming with parents thrusting strollers, Park Slope was first settled by Dutch farmers in the late 1600s. For countless years, it has been considered one of the "ten best" neighborhoods to live in the United States by various arbiters. Its combination of tangible qualities, like good schools, proximity to parkland, restaurants, leafy streets and fine architecture, all contribute to the accolades. In the 1850s, local railroad developer Edwin Litchfield began buying farmland and sold off much of it as residential plots to smaller developers. By the 1870s, the neighborhood was considered a "streetcar suburb," as numerous streetcar lines began transporting commuters to ferries that traveled to businesses in Manhattan. With the completion of Prospect Park in 1873, development accelerated, with elaborate new Victorian mansions being built to face the new park. Although smaller than Central Park, Olmstead considered Prospect Park to be his real masterpiece. By 1890, Park Slope was the wealthiest neighborhood in the United States, but the 1950s brought changes, as many of the residents moved to fancier suburbs, and the neighborhood became more middle-class Italian and Irish. In the 1960s, as the overall demographics of the city was changing, many African Americans and Puerto Ricans took up residence in Park Slope. In the 1970s, many young professionals became aware of the fine housing stock at affordable prices, and began buying rundown brownstones for $15,000 to $25,000. The neighborhood was one of the first to be landmarked in the city, thanks to local preservationists, however the crack epidemic of the '80s brought in a criminal element, and the streets were commonly the sites of shootings and robberies. Things have come full circle today, with real estate prices soaring, and classic townhouse prices starting at $3 million.

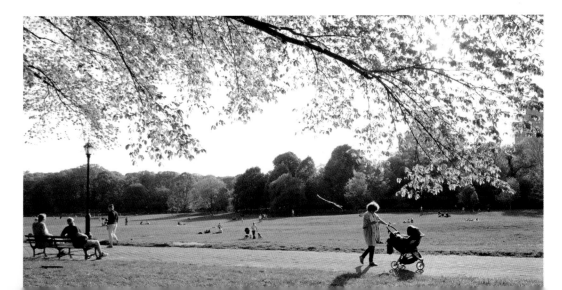

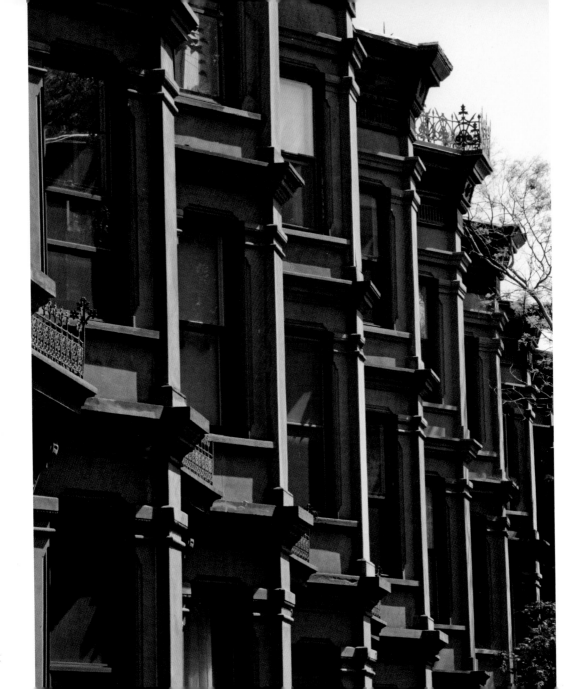

Previous spread:
page 62 (clockwise from upper left): Real estate listings on Seventh Avenue; Montauk Club detail; Café Regular on Berkeley Place; the French Second Empire William Cronyn House, built in 1867 on 9th Street, now home to a music school
page 63: A quiet summer afternoon on the Long Meadow in Prospect Park

This spread:
opposite: Neo-Grec brownstones on Berkeley Place, some with original intact metal work
this page (left to right): Woman waters plants with white porcelain pitcher from brownstone steps; walking along Sixth Avenue, St. Francis of Xavier Church in background

Following spread:
pages 66-67: Nitehawk Cinema on Prospect Park West

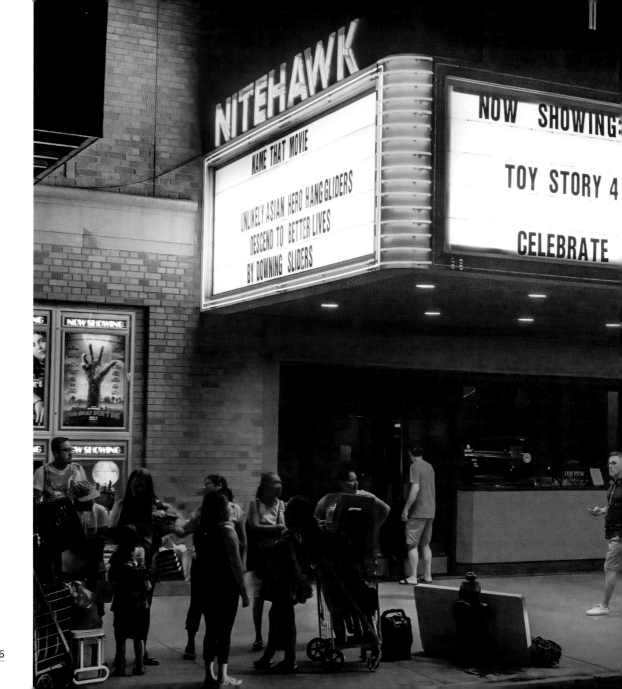

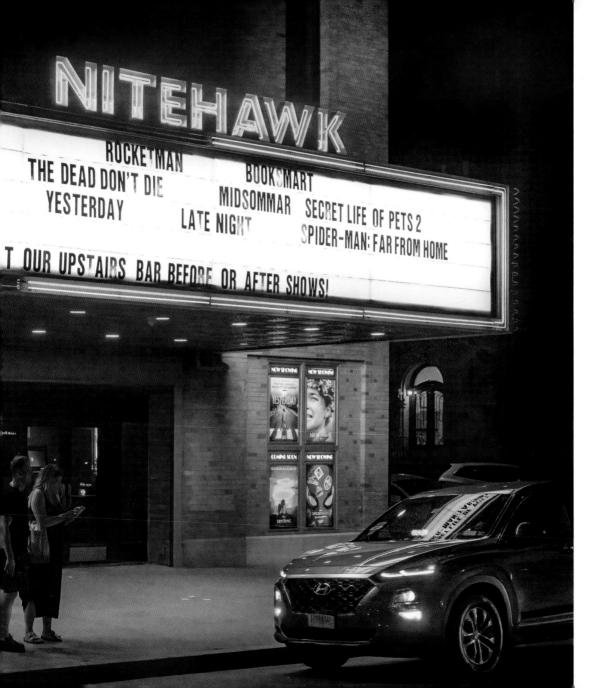

PROSPECT HEIGHTS

Comparable to Park Slope, but smaller than its neighbor across Flatbush Avenue, Prospect Heights presents many amenities that make for high levels of livability. Offering beautiful architecture, proximity to Prospect Park, the Brooklyn Botanical Garden, The Brooklyn Museum, and the Central Library, it has a lot to give. The neighborhood is also convenient to two commercial areas, contiguous to both Flatbush and Washington avenues. The elephant at the edge of the neighborhood is of course Barclays Center, a rusted steel behemoth of an arena that can hold up to 19,000 people. Home court for the Brooklyn Nets basketball team and big-name concert acts, many residents have a love/hate relationship with it. The building of Barclays, and the neighboring Atlantic Yards housing development, was very controversial in the 2000s, as eminent domain was utilized to take down smaller-scale, older buildings with rent-regulated tenants. Many neighborhood preservationists felt the low-rise character of Prospect Heights was permanently compromised. In prehistoric times, the hills of the neighborhood were formed from the debris of the glacial Laurentine terminal moraine that originated from the Arctic. The hills that constitute the "heights" are the second highest point in Brooklyn. Because of its elevation, eight-acre Mount Prospect Park was used as a lookout for George Washington during the Battle of Brooklyn, and later the site of a reservoir for Brooklyn's drinking water in the 1850s.

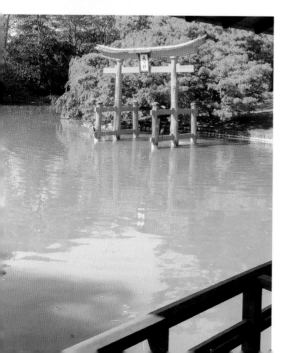

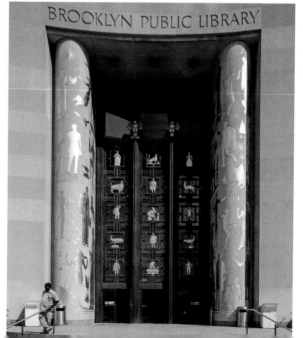

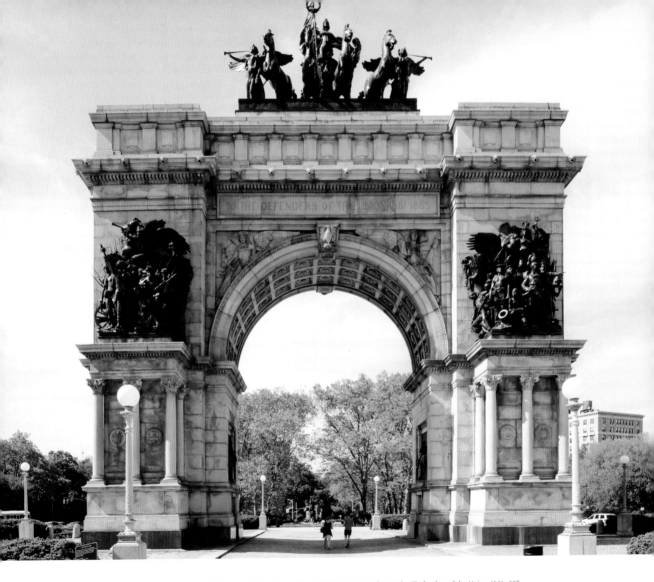

above: Soldiers and Sailors Arch in Grand Army Plaza built in 1889–92 to honor the "Defenders of the Union 1861–65"
opposite (top to bottom): Brooklyn Museum, home to one of the largest collections of Egyptian artifacts outside of Egypt; lone bicyclist rides through the plaza of Barclays Center, home to the Brooklyn Nets

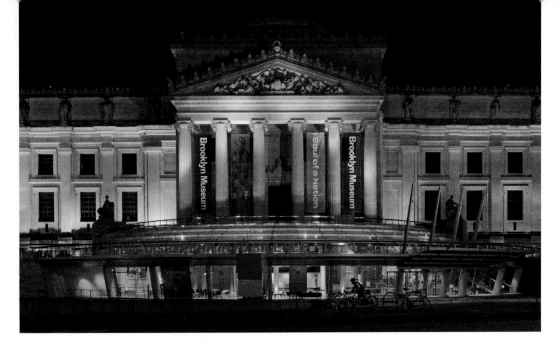

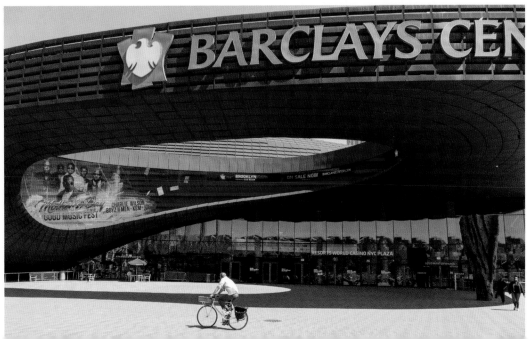

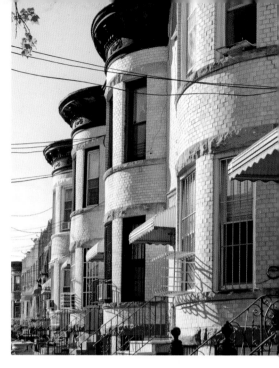

SUNSET PARK

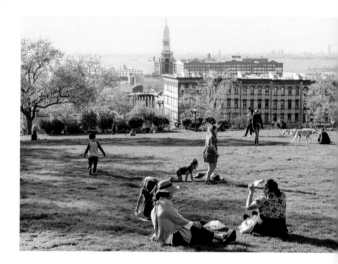

This diverse and flourishing neighborhood is both home to New York's second largest Chinatown and some of the best Mexican food in the city. For centuries, Native Americans inhabited the area and hunted venison, gathered oysters, and grew maize and other crops. In the early 1600s, the Dutch brought in enslaved African labor and began planting their own crops in the rich soil. Proximity to the water made for ease in transporting goods to downtown Brooklyn and Manhattan. Originally considered part of Bayridge to the south and Gowanus to the north, the neighborhood was renamed in the 1960s after Sunset Park, the 24-acre green space built in the late nineteenth century on a promontory overlooking New York harbor. Sunset Park is home to possibly the first non-profit co-operative housing in the country, named Alku ("the beginning"), built by Finnish immigrants in 1916. Along Sunset Park's western edge, facing the harbor, sits the 16-building behemoth called Industry City. The block-long buildings house older manufacturing companies, while some spaces have been recently renovated for use by large retail venues, and studios for the creative community. Further south is the massive Cass Gilbert–designed Brooklyn Army Terminal, built to store wartime supplies during World War I. The twin buildings sit on a 95-acre parcel that officially closed in 1970 for lack of tenants. It was renovated and reopened in 1987, readapted for use by small businesses and artist studios. The more residential section of Sunset Park is up the slope to the east, but cut off by the elevated Gowanus Expressway, which slices a dark swath into the neighborhood. During the Depression the neighborhood began declining but was revived during the war effort, because the docks and warehouses were crucial for shipping wartime supplies. Decline began anew in the 1950s, as many of the shipping businesses left for New Jersey and the Gowanus expressway was widened bringing more truck traffic. The neighborhood's fortunes improved in the '70s and '80s when large groups of Chinese and Central Americans settled into the area, opening shops and restaurants to serve the community. Today, Eighth Avenue is a vibrant, mostly Chinese American commercial strip, while Fifth Avenue caters chiefly to populations of Mexican and Central American descent.

BROOKLYN

WILLIAMSBURG

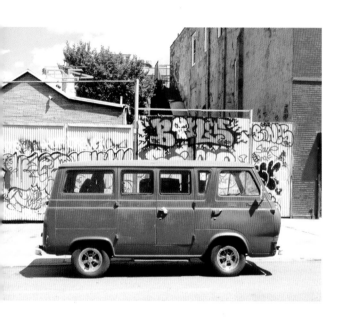

A brand onto itself, Williamsburg is ground zero for the artisanal, fixed gear, locavore, grass-fed, bespoke, craft beer, cruelty free, kale-infused way of life. Called Cripplebush in the 1600s because of the dense, overgrown swampy land, Williamsburg was part of the larger town of (Boswijck) Bushwick. The first European to settle here was Jean Mesurolle of Picardy, who built a small farm. Soon thereafter in the 1660s, many French, Scandinavians, Dutch and African slaves settled here. Thanks to its position at a deep and wide part of the East River, the 1800s brought numerous factories and ship building facilities. Some of the nation's largest industrial companies were established in Williamsburg, including Pfizer Pharmaceuticals (1849), Astral (later Standard Oil) Brooklyn Flint Glass (Corning Glass) and Domino Sugar. The mid-nineteenth century also brought German, Austrian and Irish industrialists that built hotels, distilleries, taverns and breweries. Once the Williamsburg Bridge opened in 1903, many poorer immigrants moved from the Lower East Side, and six-story tenements replaced row houses to provide accommodations for the new arrivals. By the 1920s, Williamsburg was one of the most densely populated neighborhoods in the city. The Depression brought neglect and deterioration, but escaping Nazism, many Orthodox Jews arrived, looking for a new life, opening Hasidic synagogues and schools. In the 1957, the building of the Brooklyn Queens Expressway displaced tenants, causing a loss of more than 2,000 older apartments. Public housing projects were constructed, destroying many more of the older tenements. The downturn of the '70s and '80s brought closed factories and loss of manufacturing jobs, and the blackout of 1977 resulted in looting and arson. The neighborhood finally rebounded in the 1990s, with an influx of young artists. The rebound continues to accelerate exponentially, as glass high rises and the new Domino Park line the waterfront. The sidewalks are saturated with music venues, restaurants and bars. Despite the changes, Williamsburg is still home to the three H's, Hipsters, Hasidim and Hispanics.

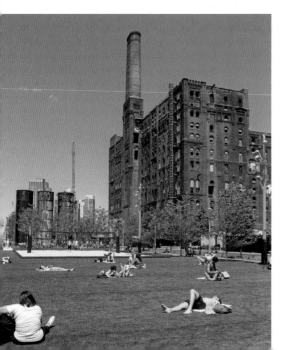

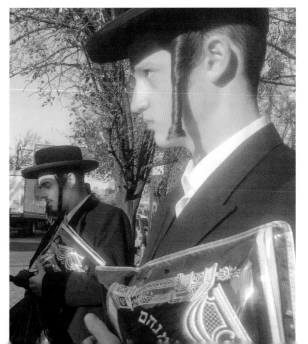

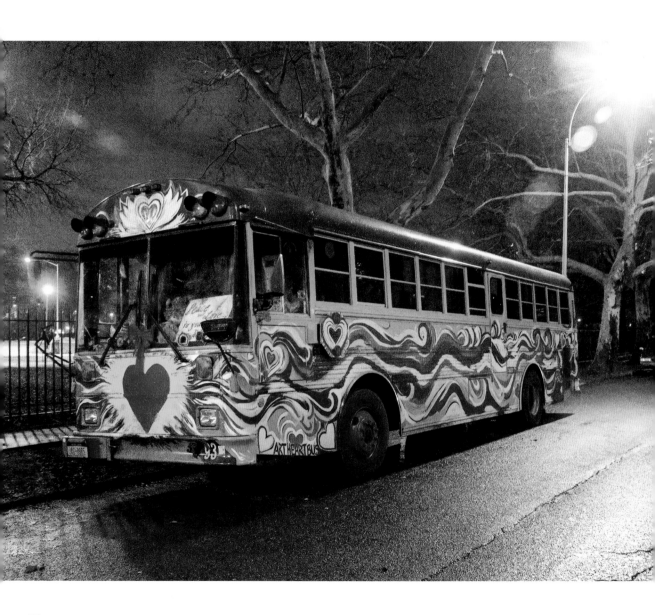

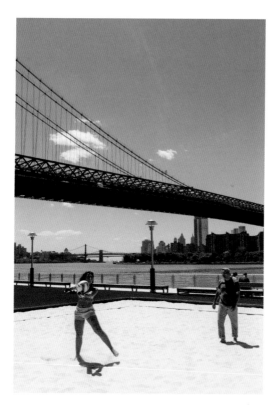

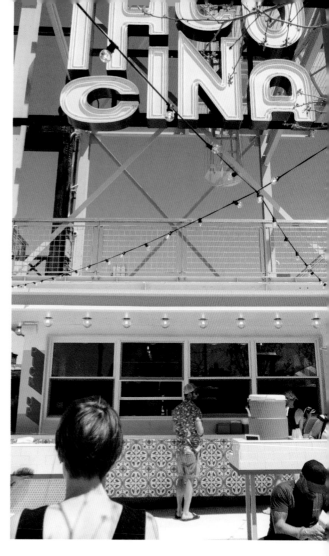

Previous spread:
page 74: Red Ford Econoline Van parked in front of gated industrial yard on South 5th Street, now home to a condominium
page 75 (clockwise from upper left): Domes of The Russian Orthodox Cathedral of the Transfiguration of Our Lord, near McCarren Park; graffitied metal water tank and smokestack near Kent Avenue; neighborhood locals; lounging in Domino Park, former Domino sugar refinery in background

This spread:
opposite: The Art Heart Bus, which hosts community art projects run by Greenpoint-based art teacher Moira Tuohy
this page (left to right): Playing volleyball in Domino Park with Williamsburg Bridge in the background; Taco Cina in Domino Park

[BRONX]

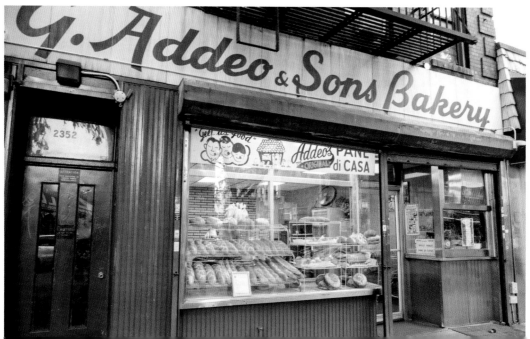

ARTHUR AVENUE

Recognized as the home turf of Dion and the Belmonts and Chazz Palminteri's childhood narrative *A Bronx Tale*, this long-time bastion of Italian American food culture is considered New York's last true Little Italy. Packed into three long blocks and a few side streets, the enclave offers a slew of Italian shops, featuring a panoply of fresh meats, seafood, baked goods, restaurants, imported specialties and sweets. The neighborhood residential mix is barely Italian now as most of the original Italian immigrants have moved on to more suburban places. These days, one finds mostly Fordham students, Albanians, and Puerto Ricans in the small apartment buildings. The community got its start in 1792, when the first tobacco company in the country, Lorillard, opened a snuff mill near the Bronx River. It was replaced around 1840 by a newer mill, which although no longer in operation, is the oldest existing tobacco manufacturing structure in the United States. Italian immigrants began settling in the area at the end of the nineteenth century, because the construction of the Botanical Gardens and Bronx Zoo offered numerous employment opportunities.

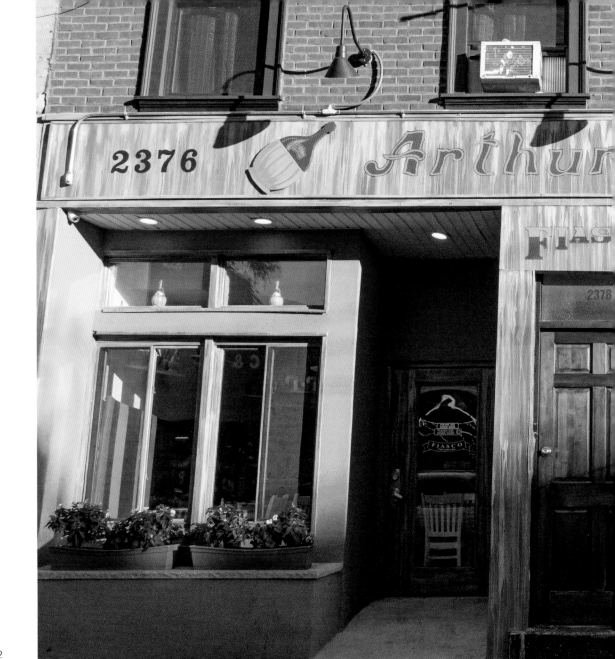

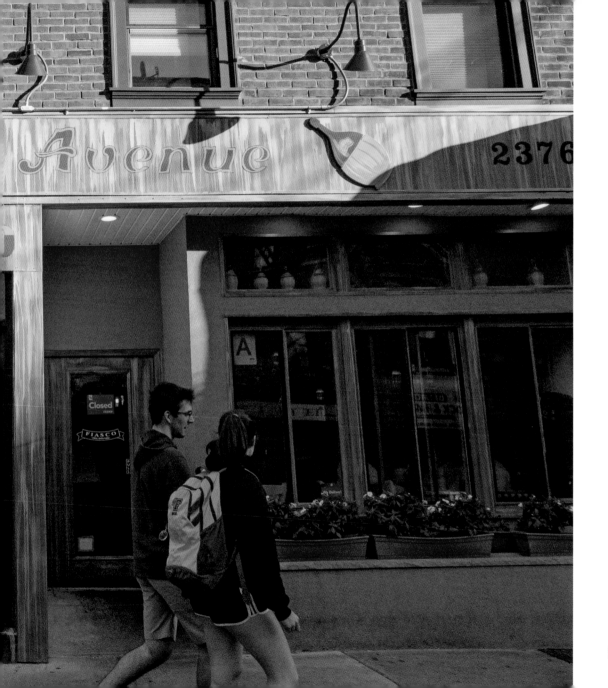

FORDHAM HEIGHTS

Centered at the crossroads of the Grand Concourse and Fordham Road, Fordham Heights is a bustling, working class shopping district in the west-central Bronx. The retail venues include discount tattoo shops, sidewalk racks of $5-$10 women's dresses, and tax preparation offices, with a smattering of lay-away furniture shops. It is also home to the glorious terracotta fronted Loew's Paradise Theater, now converted to the World Changers Church International. When opened in 1929, it was one of the first of John Eberson's "atmospheric theaters," featuring twinkling stars and moving clouds projected onto the ceiling before each movie presentation. The interior was meant to invoke a Baroque Village, with three-dimensional building facades. Residential buildings are mostly pre-World War II low-rise apartment structures. Once called Old Fordham Village, the area was first established in the English colonial era, remaining as rural farmland and country estates until the 1910s and twenties, when subway construction brought developers and new apartment construction. During the 1920s and thirties many Irish and Jews moved in from the Lower East Side and Harlem, attracted by more spacious apartments and to escape the grime of the older congested downtown neighborhoods. Like much of the Bronx, the area experienced a downturn in the seventies with "white flight" to the suburbs. It did not suffer the same destruction as the more southern parts of the Bronx and much of its housing stock remained intact.

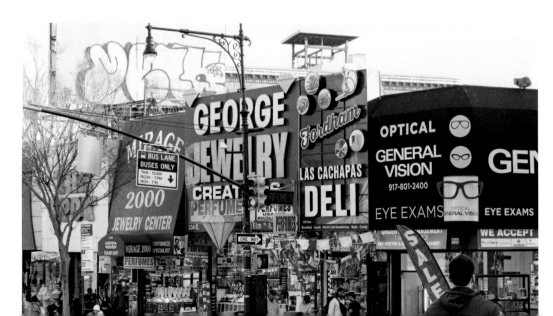

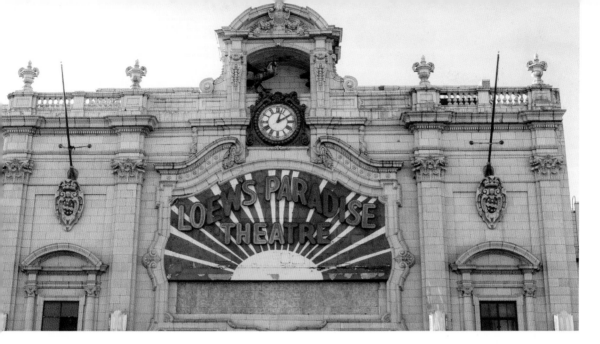

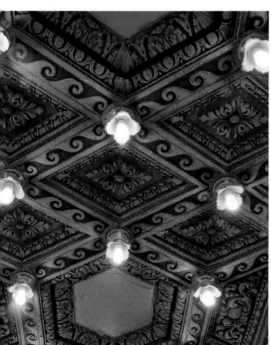

FOXHURST / LONGWOOD / SOUNDVIEW

Intertwined by elevated subway trestles and two major highways, these relatively forgotten industrial neighborhoods have achieved a slight renaissance of late because of the reclamation of the Bronx River, which bisects them. The river was once a repository of industrial outflow, but today it is lined with parkland that attracts kayakers and fishermen. Concrete Plant Park, a former cement making facility now offers green fields and direct river access underneath its pink painted industrial structures. In 1941, Clason Point Gardens was built as the first low-income development in the Bronx by the New York City Housing Authority, followed by many additional low- and high-rise subsidized projects which still define the housing stock today. The numerous 1950s highway projects include the Sheriden and Bruckner expressways, which divide and isolate many streets. The busier side streets are lined with automobile centric businesses—car repair, tire shops, detailing, parts and car washes. Recently there has been a smattering of new construction of mid-rise apartment buildings near the Sheriden Expressway. Because the neighborhoods are relatively close to Manhattan, they can offer reasonable commute times and affordable rents, which are attracting new tenants.

PORT MORRIS / MOTT HAVEN

Partitioned by the heavily trafficked Major Deegan and Bruckner elevated expressways, these two neighborhoods outline the southernmost part of the Bronx. South of the expressways is Mott Haven, named after Jordan Mott, who built the area's first iron factory in 1828, which remained in operation until 1906. The factory's product can still be spotted throughout the city in the form of manhole covers stamped "Mott Iron Works." Before WWI, the area was the piano manufacturing capital of the United States—home to 63 different piano makers that together employed over five thousand local workers. Vast swathes of the neighborhoods were leveled for the building of the highways and immense brick housing projects in the 1950s. Today many of the factories have been converted to artist lofts. Besides the lofts and projects, there are still some small side streets with historic brick row houses. Along with numerous factories, a large recycling facility, pot-holed streets and gas stations, the area has a somewhat grim industrial flavor. Although still one of the poorest congressional districts in the entire country, changes are coming to these contiguous neighborhoods. Development has jumped the Harlem River from Manhattan, leading to several high-rise, market-rate apartment projects overlooking the water in the southern part of Mott Haven.

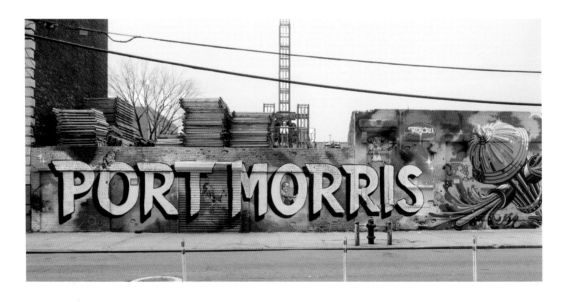

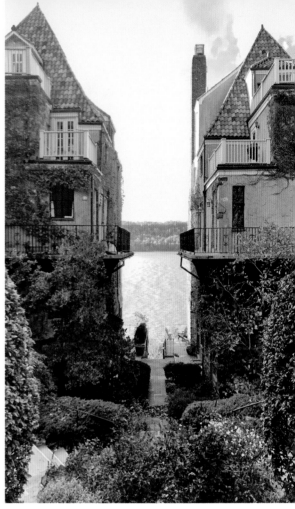

this page (clockwise from upper left): An elegant mansion set amongst mature trees; Villa Charlotte Bronte apartments, designed in 1926 by Robert Gardner, perched on a promontory overlooking the Hudson River; playing at Wave Hill gardens
opposite: Enjoying the Hudson River view from Wave Hill

Next spread:
pages 92-93: Autumn trees set ablaze a bucolic street in Fieldston

Sophisticated Riverdale and the even more exclusive enclave of Fieldston are lush arboreal neighborhoods known for majestic tree-lined boulevards and elegant mansions. Major Joseph Delafield, a veteran of the War of 1812, originally purchased much of the land area in 1829, building a lime quarry and kiln on parts of the heavily forested, hilly terrain. Years later, his son Edward erected a mansion which still stands on what is now West 246 Street and named it Fieldston Hill. Edward's sons continued developing the neighborhood as "Delafield Woods," employing the architect Dwight James Baum to design numerous houses, which were finalized in 1914. While planning placement of the streets, the engineer Albert Wheeler (at the suggestion of Fredrick Law Olmstead), decided that aligned street grids and square blocks were to be avoided. Alternatively, he created meandering avenues that showcased the mature trees and native

RIVERDALE / FIELDSTON

rock outcroppings. As streets were constructed, building commenced at a rapid pace. By 1923, there were over 80 homes completed. Since its inception as a planned community, Fieldston has retained a country sensibility. Comprising 140 acres and only 250 houses, it is a rare privately owned neighborhood within the city. The surrounding Riverdale is also home to Wave Hill, an old estate that has been converted to a public garden, featuring beautifully tiered flower gardens and specimen trees, all overlooking the Hudson River and Jersey Palisades.

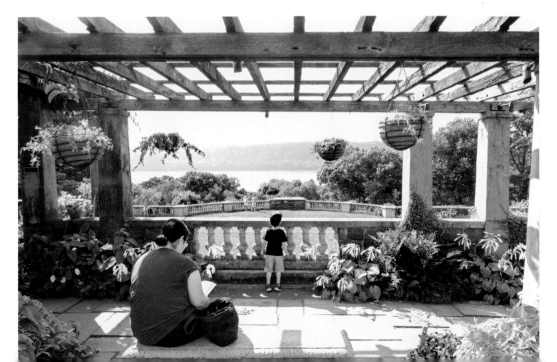

UNIVERSITY HEIGHTS

This hilly neighborhood with meandering streets takes its name from Bronx Community College, opened in 1894 as the former home of New York University's Bronx campus. The campus grounds feature a fine compendium of important architectural gems, including McKim, Mead & White's domed Gould Memorial Library and the concrete, brutalist-style Marcel Breuer lab building. Behind the Hall of Languages, sits the Hall of Fame for Great Americans, a colonnaded Neoclassical walkway, displaying bronze busts of prominent men and women, including soldiers, jurists, authors, teachers, scientists, and statesmen. Founded in 1900, it is believed to be the first hall of fame in the country. In 1973, NYU sold the campus to New York State, which converted it to the Bronx Community College, a part of the CUNY system. The surrounding neighborhood is mostly residential and made up of low-rise apartment buildings and private homes. At the northern end, the neighborhood has access to the University Heights Bridge, which crosses the Harlem River, linking to 207th street in Manhattan. University Heights has one of the highest clusters of Vietnamese and Cambodians in the entire city.

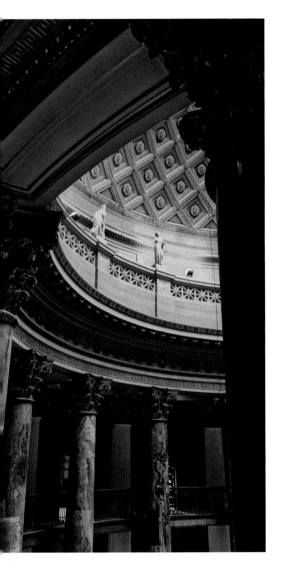

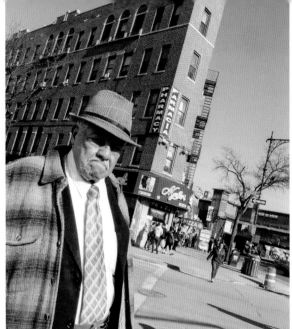

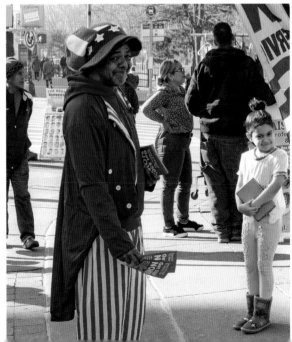

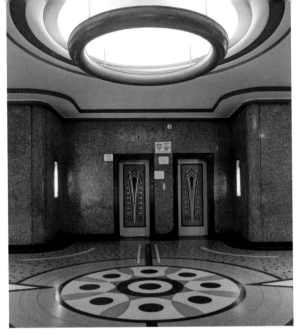

YANKEE STADIUM / CONCOURSE VILLAGE

opposite (clockwise from upper left): Art Deco apartment buildings on the Grand Concourse; terrazzo floors in a Grand Concourse Art Deco apartment house lobby; Yankee Stadium plaza; lower left baseball fans in the upper deck at Yankee Stadium

below: Abstract underwater themed glass mosaic at the "Fish Building" on the Grand Concourse—built in 1937, and designed by Ginsbern and Fine, the building is a highlight of Art Deco splendor along the Bronx's most elegant boulevard

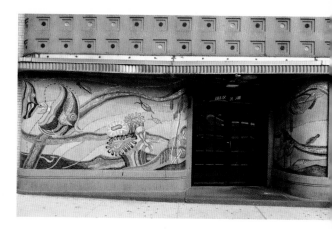

It could be said that the Grand Concourse is the spine of this neighborhood, and the heart is the new Yankee Stadium. With an average attendance of over 40,000, baseball fans quadruple the neighborhood's population during home games. Influenced by the City Beautiful movement of the late 1800s, New York City redesigned what was once called Mott Avenue into the Grand Boulevard and Concourse (later shortened to Grand Concourse), modeled after the Champs Elysees in Paris and completed in 1909. Following World War I, with the advent of the Jerome Avenue IRT, the area's first subway line, the neighborhood received its first great wave of immigration, including Jews, Irish and Italians. Situated between the Concourse and Yankee Stadium is the sublime Bronx County Courthouse, with its wide Art Deco frieze depicting the labors of various workers, including farmers, soldiers, and builders. The Concourse embraces other Deco gems, apartment buildings built in the 1930s and '40s. Near the courthouse at 1150 Grand Concourse is the "Fish Building," which presents a large colorful and mosaic of stylized fish at the entry. The original Yankee Stadium (across the street from the updated version) was built in 1923, by brewery baron Jacob Ruppert. It was completed four years after the team bought Babe Ruth's contract from the Boston Red Sox for $25,000, whose owner needed the cash to fund his Broadway production of *No, No, Nanette*. One of the greatest players of all time, the stadium was called "The House that Ruth Built" because of the many championships that Ruth helped the Yankees win during his Yankee career. The area began

a downward spiral during and after the building of Robert Moses' Cross Bronx Expressway, which was the first interstate highway built through a dense urban area. By slashing a block wide swath across the Bronx, it displaced thousands of residents from well-kept apartment buildings and cut off streets from the rest of the borough. Neighborhood stability bottomed out in the 1970s with the city's financial crisis, when many tenants left the city entirely, and landlords began burning down their apartment buildings (mostly to the South of the Concourse area) to get insurance money. What remained of the once high-quality housing stock probably helped stabilize the Concourse until today, when it has experienced a turnaround with an influx of various immigrants from West Africa and the Middle East.

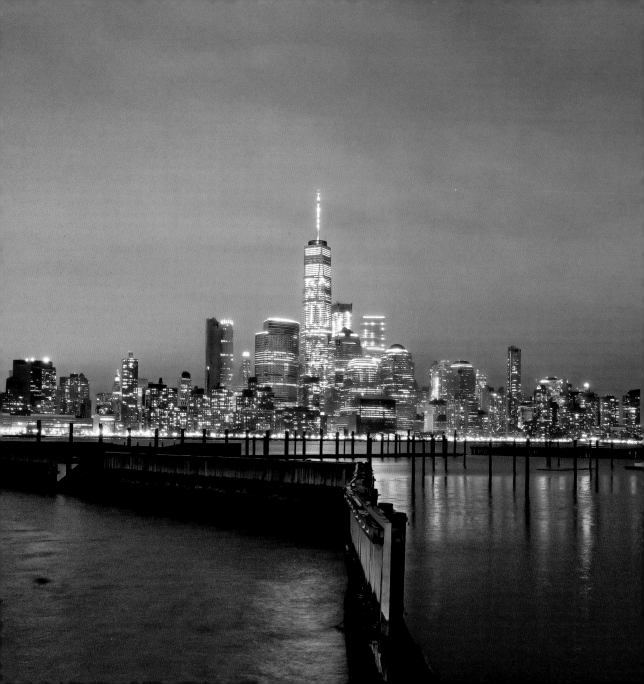

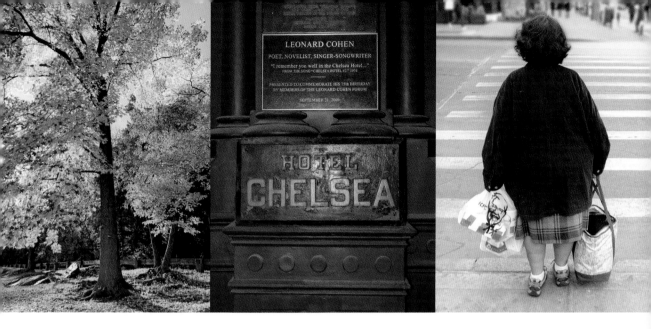

[MANHATTAN]

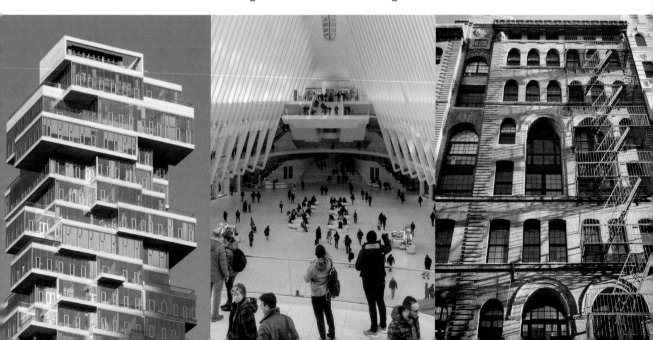

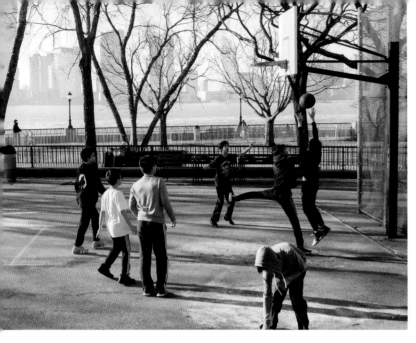

opposite (clockwise from upper left): Boys playing hoops along the Hudson River; sailboat moored at the North Cove Yacht Harbor; Museum of Jewish Heritage; strollers, bikers and joggers enjoy the late afternoon glow along the esplanade
below: Ocean liner passes in the Hudson by South Cove in late afternoon

BATTERY PARK CITY

Known both for its well-groomed park promenades and tall apartment buildings towering over the Hudson River, Battery Park City offers breathtaking sunset views of New York Harbor and the Statue of Liberty. The 36 acres of parkland and recreation space is usually filled with bikers, skaters and families taking in the fresh sea breezes. The deep marina is home base for large yachts and sailboats; ball fields and tennis courts sit wedged between office buildings and busy West Street. Once considered removed and remote from the city, Battery Park City has become more vibrant, despite the aftermath of the destruction of the adjacent World Trade Center on September 11, 2001. The addition of new apartment buildings and the numerous stores and restaurants in the mall-like Brookfield Place bring a new vibrancy. Today, development is complete, and Battery Park City is home to over 13,000 residents and thousands more workers each day. Built entirely of landfill from over 3 million cubic yards of soil and rock excavated from the original World Trade Center

construction, Battery Park City is New York's newest neighborhood. Planned in 1962 to have 92 acres of apartments and parkland, this new "city" was meant to revitalize the Hudson shoreline, as the piers in southwestern Manhattan fell into disuse and decay. By 1976, the landfill was completed, but for several years there were numerous delays starting the project. It remained a deserted empty beach that was a secret spot for sunbathers and renegade sculpture exhibits, all in the shadow of the World Trade Center towers. Finally in 1980, the first residential development, Gateway Plaza, was begun. It was one of the first tall buildings in the city to use modular construction techniques from pre-cast parts. Additional construction continued throughout the '80s, with Rector Park, a portion of the Esplanade, and the World Financial Center being completed. By the '90s, building was in full swing, as schools, residential blocks, commercial towers, parks, and public art installations all filled in the once vacant landfill.

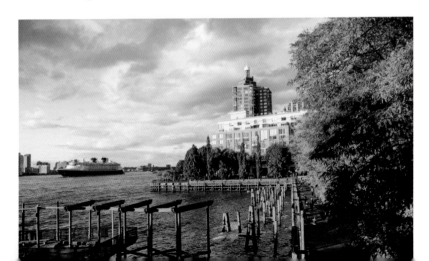

CENTRAL PARK

In the early 1850s, the terrain that was to become Central Park was but small remote settlements like Seneca Village and the Piggery District. Free Blacks and Irish farmed together, lived in small wooden shacks, and built churches and cemeteries. New York City planners anticipated the growth of the city and the need for parkland in the future, and decided to clear what they deemed a rundown enclave of shantytowns. In the mid-1850s, planning for a future park on 778 acres began in earnest. By 1857, they began clearing the land of structures, residents and farm animals, implementing the legal power of eminent domain. The following year, landscape architect Fredrick Law Olmstead and Calvert Vaux won a design competition to create a masterplan for the park, and construction began shortly thereafter. Over 20,000 workers moved hillsides, blasted rocks, laid out 58 miles of paths, bridges, and man-made waterways, totally reconfiguring the topography to create a sylvan wonderland. Workers moved nearly 3 million cubic yards of soil and planted more than 270,000 trees and shrubs. The park became a showplace and a model for urban planning for other cities throughout the United States. As the city indeed spread northward, expensive mansions were built adjacent to the park, which were eventually replaced by luxurious apartment buildings, increasing property values across all the adjacent neighborhoods. After budget cuts and the financial collapse of New York in the '60s, Central Park declined into a neglected green space with tattered fields, dying trees and rampant crime that made it too dangerous for most people to enter after dark. In 1980, the Central Park Conservancy was formed as a private/public partnership to raise money from private citizens and corporations, to work in concert with the city's Parks Department to revitalize the park. Today the park is thriving, thronged with lovers, picnickers, bicyclists, skaters, dog walkers and bird watchers (over 275 bird species have been spotted). The Central Park Conservancy continues to work alongside the NYC Department of Parks maintaining the park's plantings, trees and infrastructure.

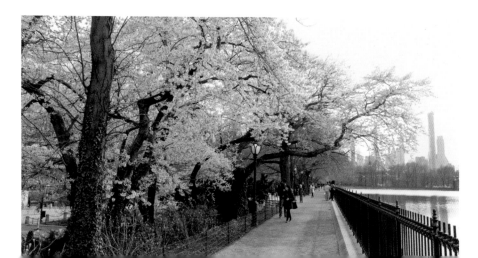

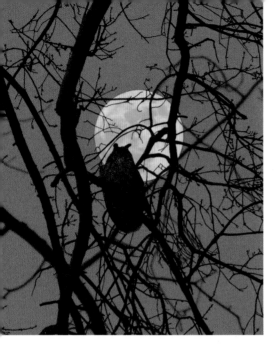

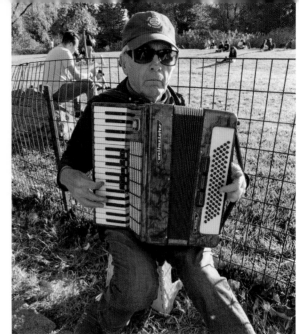

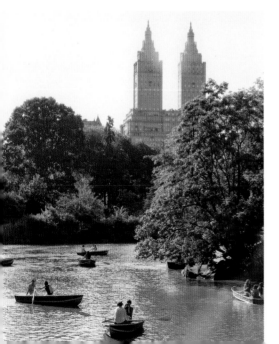

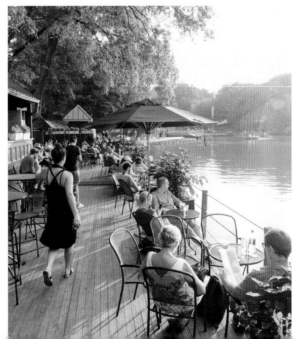

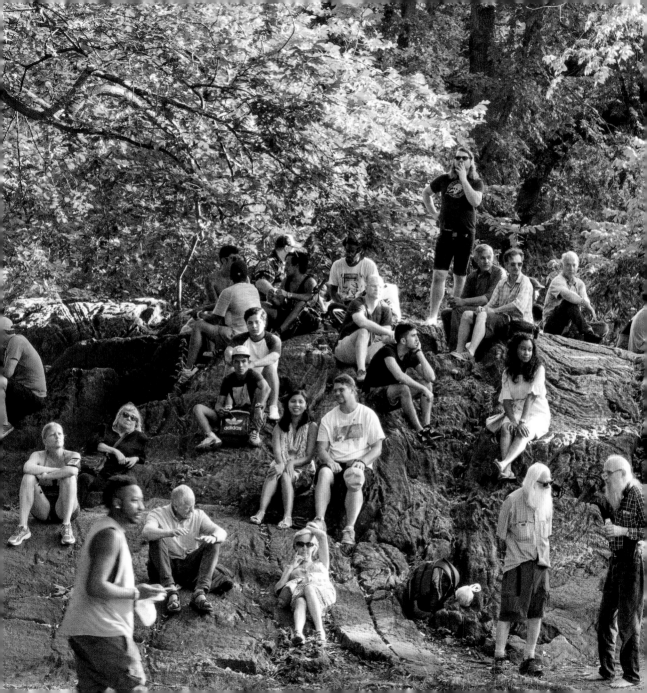

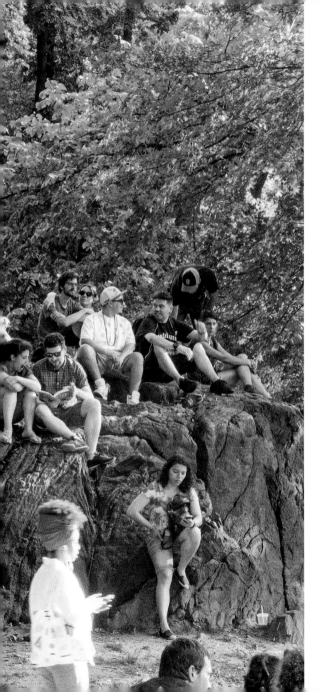

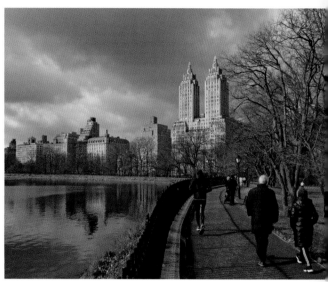

Previous spread:
page 102: Cherry blossoms along the Jacqueline Kennedy Onassis Reservoir
page 103 (clockwise from upper left): A long-eared owl begins the evening hunt on a bare branch, backlit by a January Super Moon; an accordionist serenades Sunday parkgoers; enjoying a late afternoon cocktail overlooking the lake at the Loeb Boathouse; rowboats lazily float in the lake, the twin towers of the San Remo in background

This spread:
New Yorkers enjoying a warm summer afternoon, chatting and listening to music drifting from a nearby SummerStage concert; winter joggers along the reservoir head toward apartment buildings along Central Park West, framed by the Eldorado towers in the background

MANHATTAN

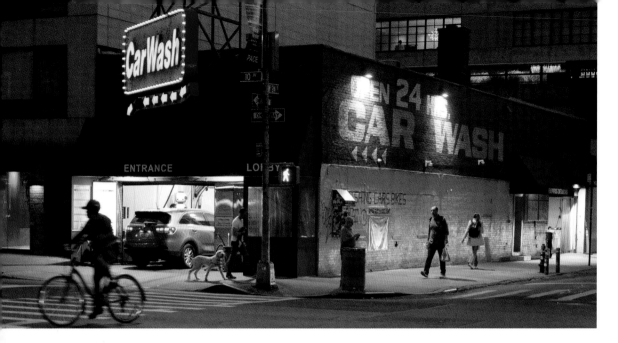

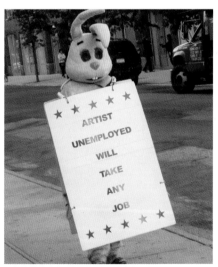

CHELSEA

It spite of the wave of gentrification that has washed over much of Manhattan, today's Chelsea has somehow retained a bit of social and architectural diversity. The structural anatomy includes grand Neoclassical commercial buildings, the streamlined Starrett-Lehigh building and the massive old Port Authority building (now Google's New York headquarters). Side streets also accommodate beautiful brick townhouses and hulking NYC Housing Authority projects. Chelsea's avenues are filled with high-end retail, restaurants, gay bars, blue chip galleries, and chain retailers on Sixth Avneue, all bordered to the west by the High Line, the former elevated freight rail line reimagined as a park. Since the mid-1800s, when the Hudson River Railroad laid the first freight tracks between Tenth and Eleventh avenues, Chelsea has been the hub of multiple New York City enterprises. During the Civil War it became a center for distilleries making turpentine and lamp fuels, lumberyards, breweries, and tenements built to house the workers. The enormous Manhattan Gas Works, which transformed coal into gas, was located at 18th Street and Ninth Avenue. In the 1880s, Chelsea became a mecca for merchandise, with the original B. Altman and R. H. Macy's locating their flagship stores along West 14th Street. Other retailers built huge stores on Sixth Avenue, facing the elevated line. Many of those original buildings still exist because they were landmarked in 1989 as part of the Ladies' Mile Historic district. In the 1890s, West 23rd Street became the city's theater row, including Edwin Booth's Theatre, Proctor's Theatre, and Pikes Opera House. Over the years, Chelsea has been home to active commercial piers and the associated

warehouses, which now have mostly been converted to working lofts and art galleries. In the 1970s, as the neighborhood was in a nadir like much of the city, an influx of gay New Yorkers moved in, attracted to the low rents and proximity to the West Village. Entire rows of townhouses remained decayed and abandoned until the 1980s, when the city's fortunes began rebounding.

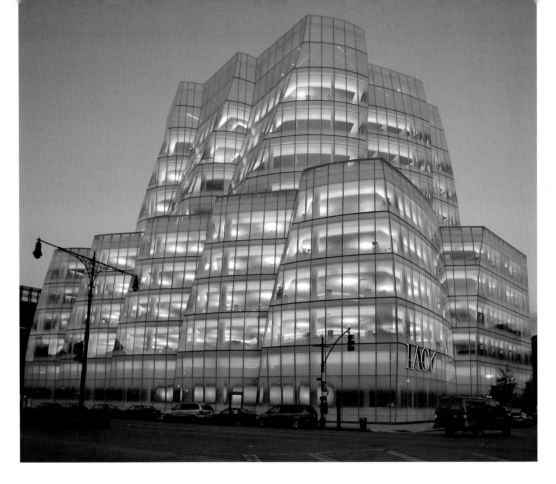

Previous spread:
page 106 (clockwise from top): 24 Hour Car Wash, one of the last working-class outposts left in the neighborhood filled with high-end condos and art galleries; in a rare moment of frivolity, Eileen, the "cranky waitress" at Peter McManus bar, welcomes customers from the take-out window; unemployed giant rabbit; School of Visual Arts theater on 23rd Street
page 107: The former Beaux Arts Siegel Cooper department store was the world's largest store when it opened in 1896—today it houses numerous retailers, including Bed Bath and Beyond, Marshalls and TJ Maxx

This spread:
above: Frank Gehry's first project in NYC, the IAC building glows from within at night. In the daytime, the glass/ceramic skin becomes more opaque, creating waves of white undulating sculptural forms
opposite (top): The iconic Empire Diner on Tenth Avenue was built in 1946, closing and almost abandoned in 1976, when the neighborhood took a downward turn. It was renovated by a team of visionaries, and today continues serving upscale diners. On the wall behind is a mural of art stars, including Warhol, Kahlo, Haring and Basquiat.
opposite (bottom): The Joyce Theater began life as the Elgin theater in 1941, and was purchased by Eliot Feld Ballet company in 1979, with the intention to turn it into a theater for small dance companies. It continues to be an important venue, presenting dance performances to this day.

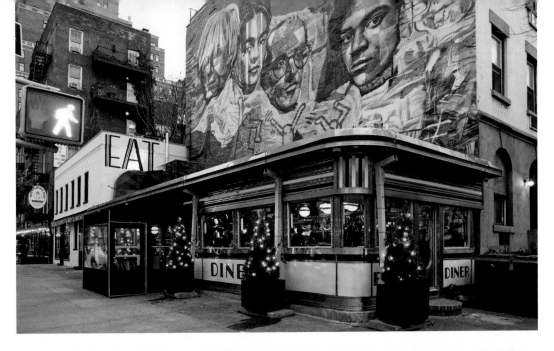

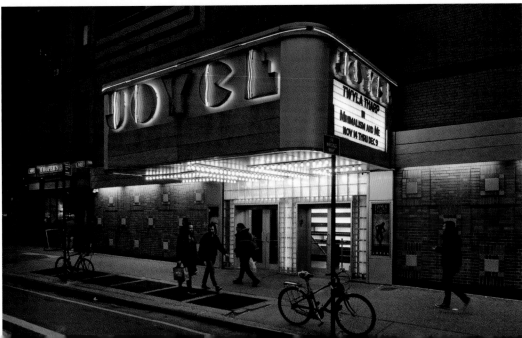

CHINATOWN

With its congested tangle of narrow streets, Manhattan's Chinatown has been the landing spot for countless Cantonese speaking Chinese since the 1870s. Gradually it expanded to become the world's largest population center of Chinese people outside of China. Today, it is only the third largest Chinatown in New York, recently surpassed by Flushing, Queens, and Sunset Park, Brooklyn. However, this Chinatown has the richest history, including opium parlors, gang warfare in the streets and illegal gambling parlors in countless hidden basements. In the 1980s, there was a flood of Fuzhounese speaking Chinese, who also settled in the outer boroughs. Centered around Canal and Mott streets, Chinatown makes up about two square miles of mostly small storefronts filled with gift shops, massage and nail parlors, Chinese family associations and scores of Chinese restaurants, featuring Szechwan-, Hunan-, Mandarin-, and Shanghai-style cuisines. Recently many of these restaurants have changed ownership and began offering Vietnamese, Thai and Malaysian foods. Above the storefronts are old tenement buildings, bedecked with metal fire escapes and ornate cornices. The earliest example of a tenement in the entire city, built in 1824, still stands—a seven-story walk up at 65 Mott Street. There are also some remaining examples of pitched-roof Civil War—era structures, but developmental pressures are bringing anonymous new glass hotels and small office buildings. These bland edifices are creeping in and replacing the old Chinatown, forever altering the character and history of the neighborhood. Tiny, block-long Mosco Street, formerly called Cross Street, then Park Street, is the last remaining original street that ran into the notorious Five Points district, memorialized in the film *Gangs of New York*. Columbus Park, bordering the western edge of Chinatown, marks the end of Mosco Street and offers a respite from the crowded tenements. It is a popular spot for go, card games, Chinese musicians, and skateboarders.

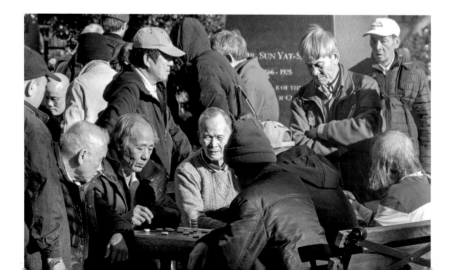

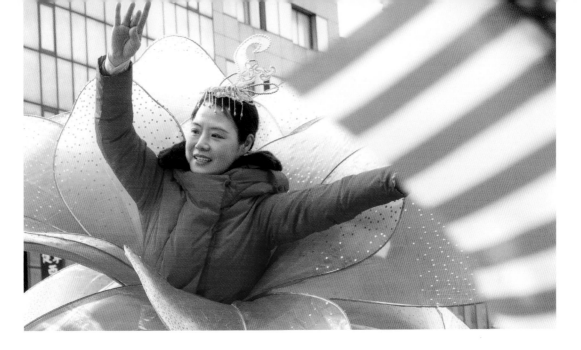

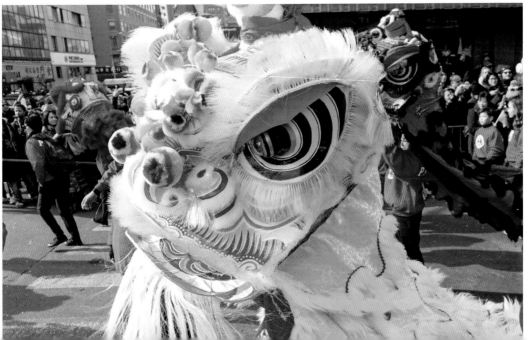

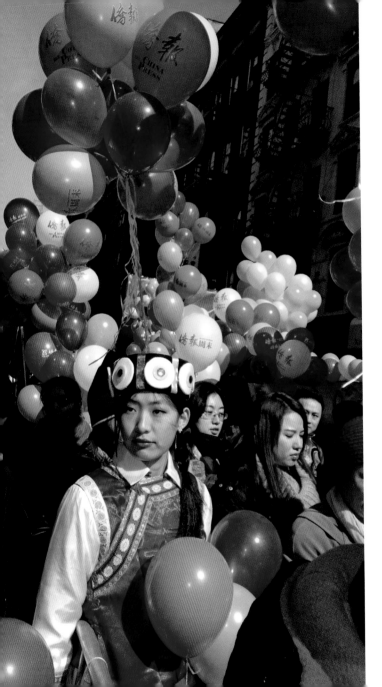

Previous spread:
page 110: Groups of men playing go (or weiqi), a
strategic board game invented over 2,500 years ago
in China
page 111 (top and bottom): Scenes from annual
Chinese New Year celebration

This spread:
left: Groups marching in Chinese New Years parade
opposite (clockwise from upper left): Canal Street
open air fruit vendors, offering rambutan and cherries;
Laughing Buddha in Mott Street gift shop; fire escape
shadows on Doyer Street; the dearly departed
"Dancing chicken" that appeared to dance when a
viewer deposited a quarter, which sent a small jolt of
electricity to the metal platform below the fowl's feet

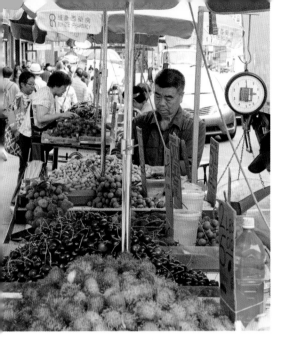

CITY HALL /
FOLEY SQUARE

The City Hall-Foley Square neighborhood is the city's governmental center, incorporating the mayor's and city council's offices, courthouses, jails and other official facilities. The area is on the site of the former Collect Pond, originally a freshwater source for Dutch settlers to the city. During spring floods, the pond would expand so that it was possible to paddle a canoe from the Hudson to East Rivers. Later, the pond became a sewage receptacle for the surrounding Five Points slums, and in 1811, it was drained because of typhus and cholera outbreaks. The first "Tombs" jail, designed to resemble an Egyptian mausoleum was built over the site in 1838 on a foundation of hemlock logs, it has since been replaced twice. The current jail and courthouse, built in 1941, in a bureaucratic Art Deco style, is still referred to as the "Tombs." Architecture around Foley Square is a collection of Roman and Greek Revival classical facades, some feature columned, entry porticos, like the Municipal and State Supreme Court buildings. The front of the United States Courthouse is graced by *Triumph of the Human Spirit*, a massive statuary by Lorenzo Pace. Farther south, the east side of City Hall Park was once called newspaper row because of the numerous daily publications that had offices there, including the *World*, the *Tribune* and *Herald* newspapers, which eventually merged, creating the *World Herald Tribune*. Between the Civil War and WWI, over 60 newspapers were published here. On the west side of the park stands the Woolworth Building, a terra-cotta, Gothic Revival masterpiece. It was the tallest building in the world when it was completed in 1913, and retained that title until the raising of the Chrysler Building in 1929. Directly south of the Woolworth stood the ornate Singer Building which was the tallest building to have been purposely demolished in the history of New York until 2019, when demolition of the Union Carbine building began.

opposite (clockwise from upper left): NYC Dept of Health designed by Charles Meyer 1935; Frank Gehry's rippled facade at 8 Spruce Street set behind the New York Municipal Building; the Woolworth Building, the terracotta marvel opened in 1903 was once the tallest in the world and known as the "Cathedral of Commerce"; rotunda murals inside the New York State Supreme Court Building *above:* Lawyers taking break in the portico of the New York State Supreme Court Building at 60 Centre Street

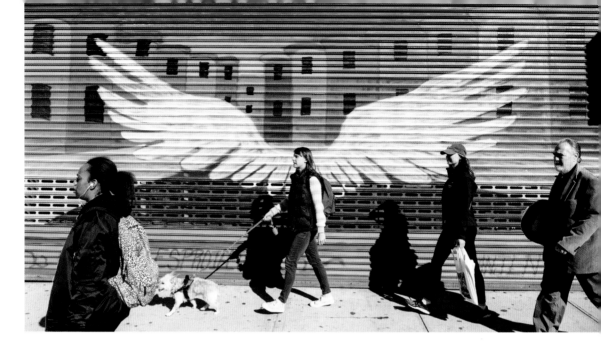

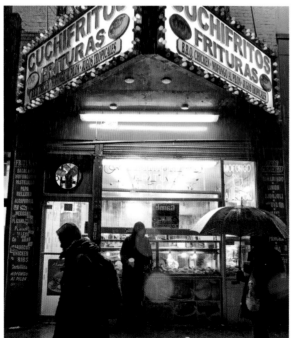

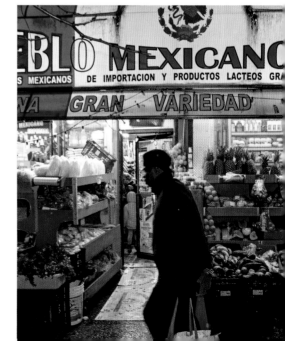

EAST HARLEM

opposite (clockwise from top): Walking along 125th Street with white wing mural; Mexican fruit and vegetable stand on East 116th Street; rainy night at a Cuchifrito Restaurant
right: Posing on East 125th Street

This eastern flank of Harlem, north of 96th Street, is currently experiencing a fair amount of new development because of its proximity to the Upper East Side and relatively reasonable rental rates. It has always had a diverse population—home to Dominicans, Puerto Ricans, Mexicans, African Americans and Central Americans. The region was mostly undeveloped until the 1800s, when free Black farmers, as well as German and Irish immigrants, were attracted to its open spaces. Railways and elevated lines made the area more accessible, as well as an extension of the IRT from Grand Central in 1919. Of course, this accessibility brought more people, including poor Eastern European Jews, Germans, Scandinavians and Irish. Beginning with a small shantytown of Italian immigrant strikebreakers who worked to finish a trolley line in the 1870s, a large Italian community developed around Pleasant

Avenue and 116th Street. Rao's Italian Restaurant anchors the corner of 114th and Pleasant Avenue, still known as a popular "red sauce" dining spot for the politically connected, and the near impossibility of getting a reservation. The neighborhood began to be known as "El Barrio" or "Spanish Harlem" after a large influx of Puerto Ricans in the 1950s and '60s. Many of the former residents made important contributions to Salsa music, including Tito Puente, Eddie and Charlie Palmieri, and Ray Barretto. Over the decades, East Harlem has experienced a great deal of urban renewal, with over 24 mammoth New York City Housing Authority projects within its borders. In the 1960s, East Harlem was the site of lootings and arson, which resulted in many years of decline. With continual high crime rates, the avenues remained empty no-man's lands, and tenements were abandoned.

EAST VILLAGE

Soon after the Dutch arrived at Manhattan Island, they expanded outward, and the wilds of today's East Village became farmland. The Dutch called it farm, or "bouwerie" (bouwerij), from which one of the oldest streets in New York (the Bowery), takes its name. When Peter Stuyvesant surrendered to the British in 1664, he was given as compensation a 62-acre plot of land that covers today's East Village, from 6th Street to the current Stuyvesant town on 17th Street. Manhattan was much narrower then, the original East River shoreline was at First Avenue for much of the East Side. In the eighteenth century, Stuyvesant's heirs began selling off plots of land for tenement construction. In 1834, they sold a plot that was to become Tompkins Square Park to the city for $94,000. After the Lower East Side, the East Village was a primary landing spot for new immigrants. The mid-nineteenth century brought a flow of Germans, Irish and Ukrainians, and later Italians and Jews from Eastern Europe. For much of the late 1800s, it was referred to as Kleindeutschland, or "Little Germany." Second Avenue became the hub of Yiddish theater at the turn of the century, with some venues holding audiences of 5,000 or more. The Bowery was an entertainment center with vaudeville, minstrel shows, saloons, flop houses, brothels and derelicts. Always a magnet for the counterculture, the name East Village wasn't really used until the mid 1950s, in order to differentiate it from the Lower East Side. The '50s and '60s brought beatniks, folk musicians, and poets, then hippies and Yippies. The punk scene exploded in the 1970s, with the opening of CBGBs on the Bowery, spawning the careers of Blondie, The Cramps, Patti Smith, Iggy Pop, Talking Heads,

Television and numerous others. The neighborhood remained a place to find cheap rents, dive bars and small independent restaurants and shops. A turning point occurred in 1988, when the city and community board decided the park had gotten out of control, with open drug sales and the overnight camping of upwards of 200 homeless people by the park's bandshell. A curfew was instituted, closing the park at midnight. Protests ensued, causing police to intervene, injuring over 100 protestors. The police were sued, and the curfew was rescinded. At 5am one June morning in 1991, Mayor Guiliani ordered the NYPD to enter the park and physically clear the squatters from the bandshell area. The park was officially closed for renovations for a year, as the bandshell was demolished, the park cleaned and restored and things were never quite the same. Rents began to escalate and the neighborhood suffered an overwhelming flood of young bankers and hedge funders who liked the idea of "slumming it," while paying $3,000 a month for a studio apartment in a walk up tenement. In the summer the neighborhood still attracts "Crusties," the roaming youth known for their tattoos, piercings, soiled clothes and backpacks. Along with their pitbull companions, they are frequently seen taking up residence on the sidewalks and in Tompkins Square Park.

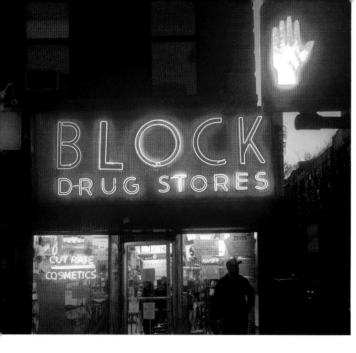

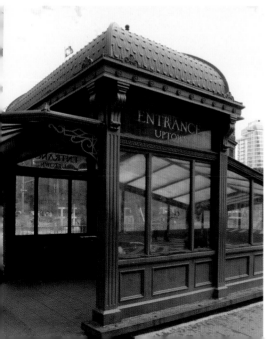

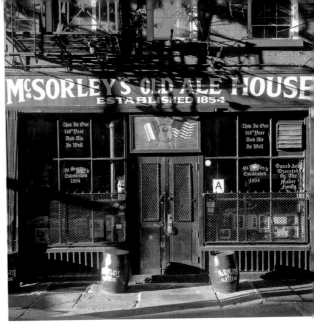

Previous spread:
page 118: Beaver terracotta panel at Astor Place station representing the accumulation of Astor family wealth in beaver skin trading
page 119 (clockwise from upper left): Block Drug Store neon lights up a stretch of Second Avenue; the spinning Alamo, or Astor Place Cube, by Tony Rosenthal, 1967; detail of the 1889 Schuetzen Hall at 12 St. Marks Place; at Astor Place is a modern replica of the original glass and metal subway kiosks that were built throughout the city in the early 1900s for the first subway stations

This spread:
opposite (clockwise from upper left): Row of townhouses on Stuyvesant Street, attributed to James Renwick; McSorley's Old Ale House, established in 1854, is the oldest Irish Pub in NYC; The Strand Bookstore, founded in 1927 by Benjamin Bass, is the largest independent bookstore in New York, one of the last holdouts in a neighborhood once filled with bookstores, known as "Book Row"
this page (top to bottom): The Orpheum Theater on Second Avenue; ceiling detail of the City Cinema Village East, which began life as the Yiddish Arts Theater in 1926

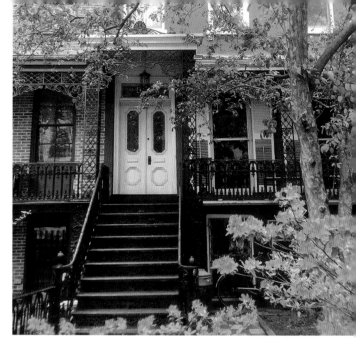
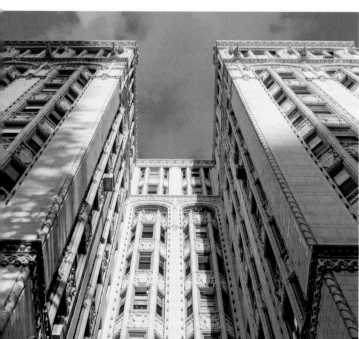

GRAMERCY / GRAMERCY PARK

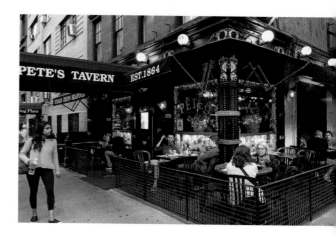

opposite (clockwise from upper left): Multi-tiered bird house in the park; rhododendrons in bloom; looking through park and blossoming cherry trees; 36 Gramercy Park East, a 1908 terracotta clad apartment building overlooking the park

right: Once a favorite haunt of the writer O'Henry, Pete's Tavern on Irving Place is one of the oldest taverns in NYC and still retains its original interiors from 1899

Next spread:
pages 124-125: 1940s cars parked for film shoot

In the 1830s, Samuel B. Ruggles purchased and drained the swampy land that was to become Gramercy Park. From its inception, as a private, fenced two-acre greenspace, the streets surrounding the park were always meant for the moneyed class. The designation of Gramercy Park as a neighborhood has expanded through the years beyond the streets on the park to include blocks bordering the East Village and the Flatiron district. However, an actual location around the gated enclave between 20th and 21st streets still carries the most prestige. Those streets on the park provide an air of architectural refinement and variety, with extravagant high-stooped townhomes and dignified co-ops. At 15 Gramercy Park South is the former Samuel Tilden House, the largest Victorian mansion in the city. Today it is used by the non-profit National Arts Club for its varied arts programming, and in 1898 was the first private club in the city to admit women on an equal basis. Adjacent to the Arts Club, sits number 16, the Players Club

mansion, founded in 1888 as a clubhouse for actors by the performer Edwin Booth (brother of John Wilkes Booth). Booth hired Stanford White to redesign the interior for an upstairs private residence, a public dining hall and various interior meeting rooms. At the corner of 20th Street and the park stands the oldest co-op in the city, the 1883 red stone Romanesque revival 34 Gramercy Park East, the last building to have a hydraulic elevator in the city, which was finally electrified in 1994. The surrounding neighborhood includes peaceful Irving Place, home of Pete's Tavern, continuously serving alcohol from 1864, and once a favorite haunt of the writer O. Henry. Nearby Third Avenue and Park Avenue South provide resident necessities including various restaurants, banks, and bars. Four-acre Stuyvesant Park, a sort of public version of Gramercy Park on Second Avenue, was chartered in 1836 and surrounded with the oldest wrought iron fence in the city, enclosing mature elm trees, plantings and benches for relaxing.

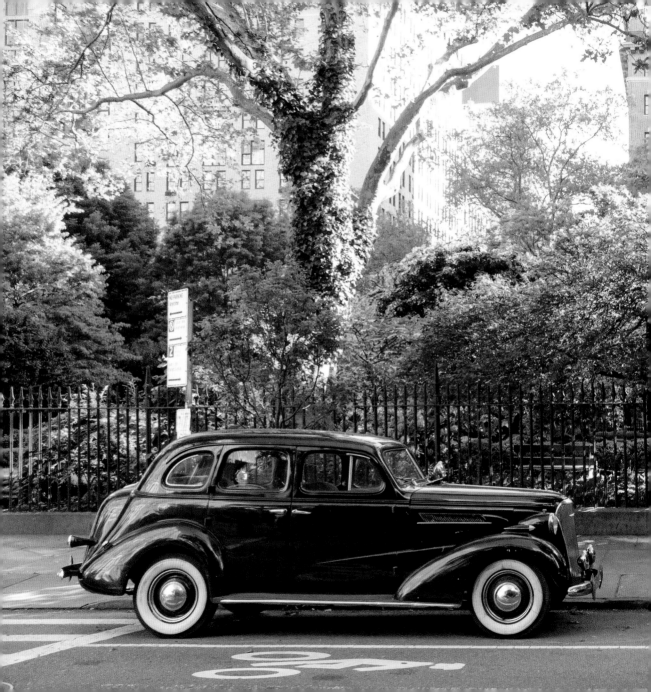

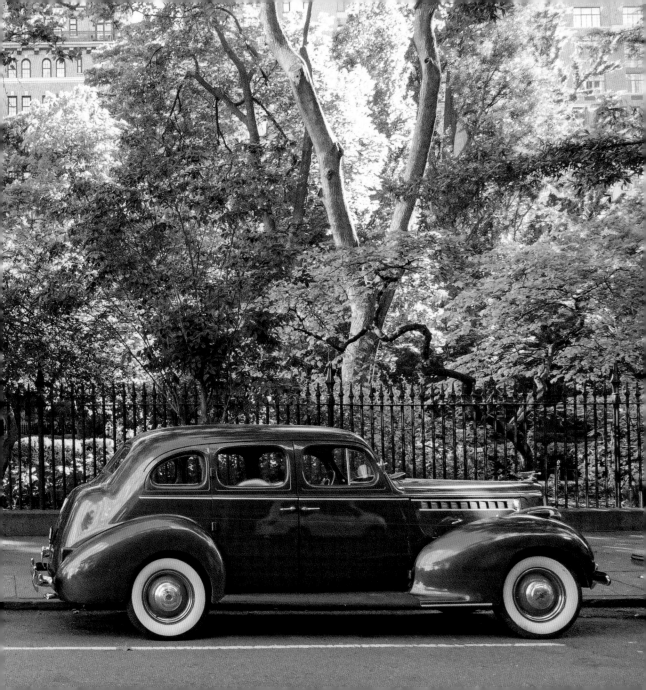

GREENWICH VILLAGE

Greenwich Village is practically a cliché of a neighborhood. There are actually scores of charming, picturesque streets, lined with majestic trees and high-stooped townhouses, where swaths of sky are visible. Regrettably, the days of those townhouses accommodating romantic $50-a-month cold-water artists' garrets, and beret wearing musicians groovin' to jazz in a dark subterranean club, nursing cheap beers, are a thing of the past. Frequently regarded as a magnet for artists and bohemians, in reality the Village has some of the most coveted and expensive real estate in all of New York. Those enchanting townhouses on tree-lined side streets can fetch tens of millions of dollars. Many jazz clubs, like the Blue Note, can cost $50 a set, with a two $15-a-drink minimum. Surprisingly, as far back as 1939, people were lamenting the loss of the "real" village. From the WPA Guidebook to NYC: "The Village tearooms and night clubs, for the most part no longer the haunts of the bohemian, were patronized largely by out-of-town tourist and sensation seekers." The book complains, "Rents were rising as the well-to-do and white collar workers, attracted perhaps by the glamour of the address, moved in." Greenwich Village first attracted droves of new inhabitants in the late 1700s, when an epidemic of yellow fever brought them "uptown" to the "countryside." Another epidemic, in 1822, attracted tens of thousands more. The practice of welcoming the avant-garde and alternative culture started in the late 1800s. The village always accommodated artists, open gay expression and bohemian culture, as countless poets, painters, performers, progressives, radicals, and other free spirits have found refuge here. Many well-known painters, like Winslow Homer and Fredrick Church, produced their art in the Tenth Street Studio Building, designed by Richard Morris Hunt in 1857. The Judson Church was one of the first to host performance art in the early 1960s. The Stonewall riots began because angry members of the gay community took action and rose up against police harassment and brutality. Over the years, the Village has offered haven to Emma Goldman, Edgar Allan Poe, Jackson Pollock, Bob Dylan, Margaret Sanger and Eugene O'Neill. While the sidewalks today are actually filled with mostly NYU students and tourists, one can still find art movies at the IFC Center on Sixth Avenue, a few reasonable jazz joints, like Small's on West Tenth Street, comedy clubs a plenty, a friendly chess match, and dozens of cheap pizza or falafel spots on MacDougal Street.

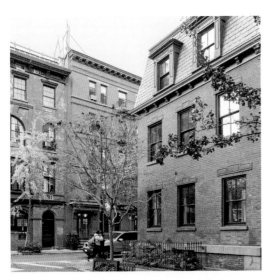

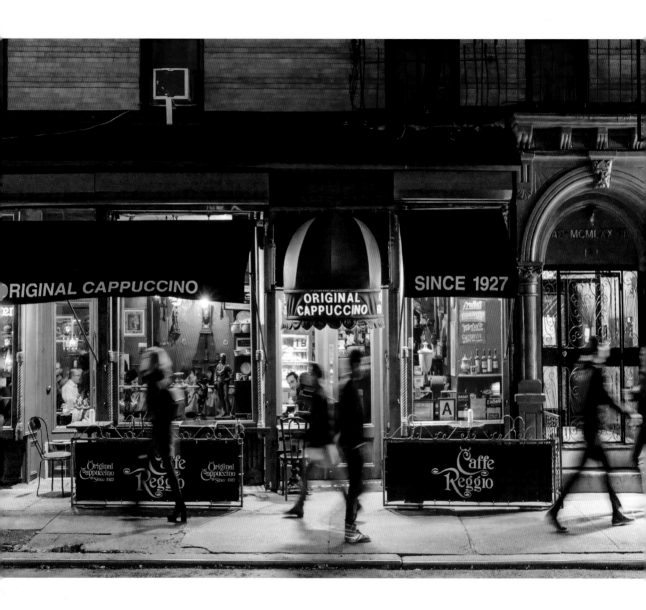

Previous spread:
page 126: 1970 MG GTB festooned with flowers on
East 12th Street
page 127 (clockwise from upper left): Barrow and Commerce
streets in the West Village; tower of the Jefferson Market Library,
originally the Third District Courthouse, designed in the High
Victorian Gothic style by Frederick C. Withers in 1877; the grocery
at Tea and Sympathy stocks a wide variety of favorite British
Tea, sweets and merchandise; skeleton puppets at the annual
Halloween Parade

This spread:
opposite: Café Reggio, a coffeehouse fixture on MacDougal Street
since 1927
this page (top to bottom): The Washington Square Park fountain;
neon of the White Horse tavern, which was once known as the
center of Bohemian culture in NYC, welcoming the likes of
Dylan Thomas, Jack Kerouac and other beat poets in the
1950s and 1960s

HAMILTON HEIGHTS / CITY COLLEGE

Anchored to the south by the Gothic Revival–themed City College, Hamilton Heights is a tightknit community with an astounding quantity of splendid original architecture. The neighborhood is named for Alexander Hamilton, whose 1802 home, called Hamilton Grange, is set down the hill from City College upon a green lawn and open to the public for tours. Development in the Heights began in 1886, with townhouses and tenements replacing farmland. Architectural styles comprise Romanesque Revival, Queen Anne, Dutch and Flemish revivals, French Renaissance, Colonial and Federal styles. Financially comfortable Black families began relocating to the northern section of Hamilton Heights in the 1930s, creating an enclave called "Sugar Hill," home to many well-known African Americans including, W. E. B. DuBois, Thurgood Marshall, Adam Clayton Powell Jr., Duke Ellington and Cab Calloway. Most of the Sugar Hill area is still intact today. Many of the grey stone buildings of City College were built from Manhattan schist, excavated from the construction debris of the nearby IRT #1 subway extension on Broadway and 137th Street.

below: The original lavender colored 137th Street City College station terracotta, from 1904, which now sits in the collection of the New York Transit Museum—the three heads represent past, present and future
opposite (clockwise from upper left): Elegant townhouses along Convent Avenue; colorful apartment house and curtains on St. Nicholas Avenue; the almost black concrete, seemingly random windows and articulated facade makes for very distinctive affordable housing in a design by David Adjaye; detail of gothic tower at City College

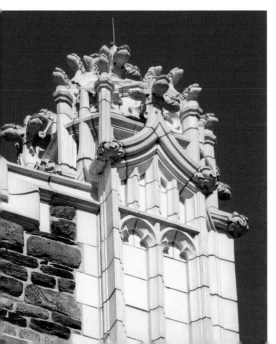

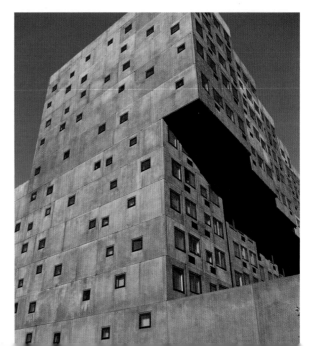

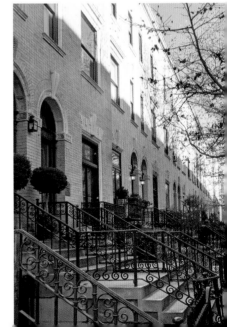

HARLEM

The borders of central Harlem are roughly defined as North of Central Park from 110th Street up to 145 Street. One of the most historically important African-American neighborhoods, its culture and history are reflected in many of the street names, including Malcolm X, Martin Luther King Jr., Adam Clayton Powell Jr., and Fredrick Douglass boulevards. Originally a Dutch village named after Haarlem in the Netherlands, New York's Harlem has gone through numerous cultural and population shifts over the centuries with blocks of Irish, German, Italian, and Jewish residents settling here in the late nineteenth century. Black Americans began arriving in great numbers after 1905, during the "Great Migration." This residential boom fueled the "Harlem Renaissance," in the arts, literature, music and dance. The renaissance was short lived however, as the depression, and loss of good paying industrial jobs after WWII, led to increases in impoverishment and criminality. Much of Harlem was ravaged in the '60s and '70s because of population loss, arson, property abandonment and drug use. The last two decades have seen a great rebound, as real estate values have surged throughout the city; many of the historic buildings in Harlem have also been rehabilitated. Entrepreneurs have opened buzz-worthy new restaurants, and an abundance of West African immigrants have invigorated many streets. In spite of all the changes, Harlem has managed to retain some of its history, including Striver's Row, the Apollo Theater, Sylvia's Soul Food Restaurant and dozens of blocks of architecturally significant townhouses and tenement buildings. Harlem has always been

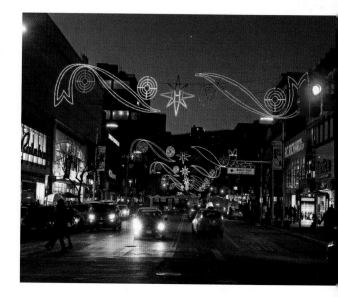

a mecca for religious institutions, host to almost 400 churches. Denominations include Baptists, Pentecostals, Methodists (generally African Methodist Episcopalian, or "AME"), Episcopalians, Allah School in Mecca, The Nation of Gods and Earths, better known as the Five Percenters, the Church of Jesus Christ of Latter-day Saints and Roman Catholic. The Abyssinian Baptist Church, led by the Rev. Calvin Butts, is particularly important to the community because of its large congregation and real estate holdings.

MANHATTAN

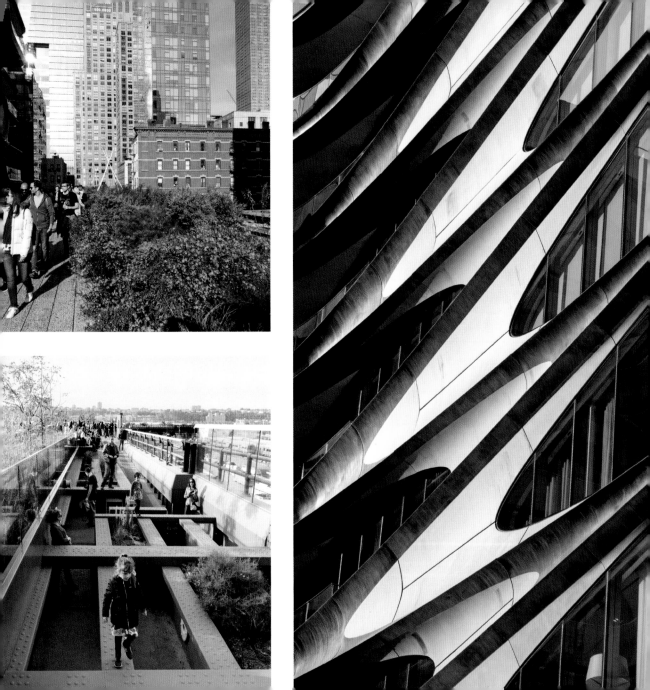

HIGHLINE

opposite (clockwise from upper left): Visitors pass a patch of New England asters; 520 West 28ᵗʰ Street, Zaha Hadid's first residential building in NYC; exposed steel girders provide a play area for children

This elevated steel railway overpass was built originally to take street-level freight trains off the busy avenues of the West Side of Manhattan. In order to deliver food to nearby warehouses, steam belching freight trains ran straight down Tenth Avenue, then referred to as "Death Avenue," because over 500 people had been killed there by 1920. To alleviate the problem, the railroads hired mounted men on horseback to patrol the tracks with red flags to warn pedestrians of oncoming train traffic. In 1924 the city's transit commission dictated that all trains be removed from street level. Construction began shortly thereafter, and the Highline opened for business in 1933, allowing millions of tons of food to be delivered directly from elevated tracks, removing trains from pedestrian streets. Over the decades the line became idle, as trucks were making most deliveries, and warehouses and factories were

moving out of the city. Sections of the southern parts of the Highline were demolished as residential developmental pressure increased. The elevated tracks were neglected, but slowly in their place, a lush meadow of wildflowers and trees grew spontaneously. Many city officials, including Mayor Rudolph Guiliani, wanted to demolish the overpass because they felt it was an eyesore, but small groups of citizens advocated for its reuse. Thankfully, their foresight and tireless efforts led to the very sensitive redesign by James Corner Field Operations; Diller, Scofidio+Renfro; and Piet Oudolf. Today the park features over 500 species of native plants and trees, unique views through the cityscape, and beautiful pathways. It is one of the most popular tourist spots in the city, attracting over six million visitors a year, and an integral part of the huge real estate resurgence of the far West Side, and Hudson Yards.

MANHATTAN

INWOOD

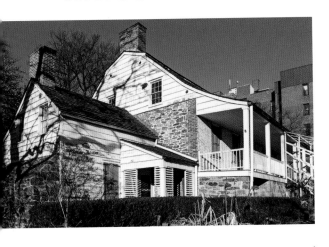

In 1625, Inwood, at the northernmost tip of Manhattan, was the setting of the Dutch making their "purchase" of the island from the Lenape Indians. Historians suggest that in retrospect, both parties may have misinterpreted this exchange of goods, as the Lenape might not have understood the rules of property ownership and believed that the bounty of the land was plentiful for all to share. The trading of beads and other goods may just have been a sign of trust and friendship. The Lenapes continued living in this area throughout the seventeenth century, as it was overflowing with riches. Surrounded on three sides by water, the shorelines were filled with fish and oysters, and the dense forests teemed with animals to hunt. By the 1800s, Inwood became a place that wealthy New York families built country estates. In 1916, the New York City Parks department purchased an old charity house for women and demolished the buildings to use the land for parks. Today that land is part of 196-acre Inwood Park, the last native forest on Manhattan Island. *The W. P. A. Guide to New York City* describes Inwood as "rivers and hills insulate a suburban community that is as separate an entity as any in Manhattan." Around 10 miles from Midtown, many parts of Queens and Brooklyn are closer to Manhattan than Inwood. The hilly sylvan neighborhood is filled with parks and rugged rock outcroppings. West of Broadway, one finds steeper hills, river views and more pre-War cooperative apartment buildings. To the east of Broadway, a visitor might see more slightly run-down rental properties, car repair shops, gas stations and a vast New York City Transit Authority subway train storage yard. The eastern part of Inwood is also home to Sherman Creek, a shallow inlet to the Harlem River, today home to egrets and herons. Before a massive cleanup in the early 2010s, the creek was a dumping ground for old tires and abandoned cars.

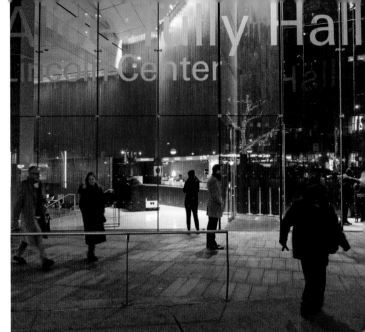

LINCOLN CENTER

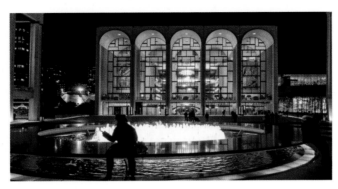

opposite (clockwise from upper left): Musicians chatting outside Alice Tully Hall;
Alice Tully before a performance; David Geffen Hall *above:* Lincoln Center Plaza

Established by the Dutch as part of the village of Blooming Dale, as a wealthy bucolic area with large country homes, over the centuries it became a Black and Hispanic neighborhood known as San Juan Hill. The narrative of *West Side Story* derived from the local residents' frequent scuffles over territory with the Irish gangs from Hell's Kitchen to the south. Some of the film's opening scenes were filmed on the actual streets, before demolition began for the massive urban renewal project that was to become Lincoln Center. Slum clearance had already begun in the 1940s, to the west of Tenth Avenue, as the New York Housing Authority called the area "the worst slum section in the City of New York." The planning for more revitalization began in the 1950s, under the direction of Nelson Rockefeller, who helped bring together all the moving parts, including raising half of the money and securing the multiple cultural tenants. The Metropolitan Opera, then located on 39th Street, had been looking for a new home since the 1920s. The New York Philharmonic had lost its lease with Carnegie Hall that was then slated for demolition. Fordham University, the Julliard School and the New York Ballet also committed, and construction commenced in the early 1960s. Of course, Robert Moses had a hand in the huge undertaking, condemning existing properties and overseeing the construction. The master planners were Rockefeller's go-to firm, Harrison & Abramovitz. The new theaters included the Metropolitan Opera House, with 3,900 seats; the New York State Theater, designed by Philip Johnson, with seating for 2,713; Avery Fisher Hall (now David Geffen Hall), 2,738 seats; Alice Tully Hall, with 1,095 seats; and the Vivian Beaumont Theater, by Eero Saarinen—1,080 seats. The complex was redone in 2012, by Diller, Scofidio+Renfro; FX Fowle; and Beyer Blinder, Belle, who modernized much of the pedestrian areas and reconfigured some exteriors to make them more open and appealing.

LITTLE ITALY / NOLITA

Once a teeming tenement district whose humanity spilled through the streets from Canal to Houston, Little Italy was permeated with pushcarts, food shops, barbers, and bakeries, all surveyed by old women hanging over their window ledges above. Presently, Little Italy is but a shadow of its former self, scattered on a few blocks, with but a sprinkling of food stores, "kiss me I'm Italian" t-shirt shops, and restaurant hawkers, reeling in tourists with quick sales pitches. The formation of Little Italy began with an early surge of Italian immigrants in the 1840s that settled in the Five Points district, directly to the south. As Five Points basically became an open sewer, and crime flourished, those that could settled further north above Canal Street, where the tenements were a little newer. The neighborhood continued to grow, with the largest bloom of Italians coming in the 1880s, fleeing economic hardship in their homeland. Between the years 1880 and 1920, nearly four million Italians settled in America, with hundreds of thousands in New York City. By 1920, over 800,000 Italians, both foreign and native-born, lived in the five boroughs.

In the 1950s, the neighborhood was still half Italian, with Italian still spoken in the many shops catering to the locals. According to the 2000 census, only 44 Italian Americans remained, but the area still retains a vestige of Italian specialty shops like Albanese's Meats and Poultry, Ferrara's Bakery, DiPalo's Specialty Shop, and the St. Patrick's Old Church on Prince Street, with its high brick walled cemetery. The neighborhood is probably more Chinese to the south of Broome Street and more high-end boutique north to Houston Street. The entire area was considered Little Italy, but today, in real estate parlance, North of Delancey is now thought of as Nolita (North of Little Italy). Tiny Petrosino Park on Centre Street and Kenmare is named after the Italian immigrant who became an NYPD police lieutenant, heading up the "Italian squad." This unit investigated the notorious Black Hand organized crime network that extorted local stores for protection money. If businesses did not pay, there would be mysterious explosions and fires. In 1909, there were over 125 incidents in Little Italy alone. Thanks to the Italian Squad's work, by 1920, the attacks had ended. However, Lt. Petrosino was killed in the line of duty while investigating Black Hand associates in Sicily.

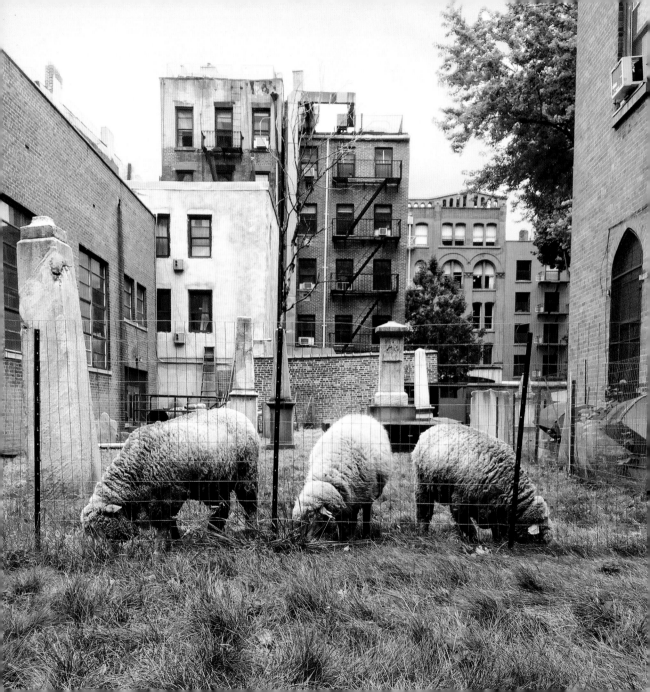

Previous spread:
page 140: Cheese in the window of Alleva Dairy store on Grand Street, whose owners claim it is the oldest cheese store in America
page 141 (clockwise from upper left): Upper dome of the Police Building on Centre Street, originally the home of police department of the newly consolidated City of New York, now very high-end condominium, with one of a kind apartments carved out of the various domes, cupolas and terraces; metal shutters on the Puck Building; gilded statue of Shakespeare's character Puck, the namesake of *Puck* magazine, which once called the building home; tending booth at San Gennaro Festival

This spread:
opposite: Sheep help trim the grass at Old St. Patrick's Cemetery grounds on Mulberry Street
this page (clockwise from left): Colorful balloons above a shop on Elizabeth Street; practicing the time honored pasttime of surveying the street from one's tenement window ledge; bicyclist in blue on Prince Street

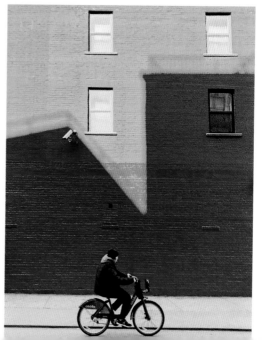

LOWER EAST SIDE

Probably no other neighborhood in the United States tells the immigrant narrative better than the Lower East Side. Black and white period photographs taken at the turn of the twentieth century, show streets teeming with masses of people, pushcarts, and horses. With the industrial boom of the nineteenth century, and the need to fill factory jobs, the first great waves of migration began with Germans in the mid-1800s, followed by Irish, Italians, Eastern European Jews, etcetera. These arrivals took the only housing available at the time, including small, shared apartments in wooden walk-up tenements and rookeries—single-family houses that had been divided into multiple single rooms. Soon the Lower East Side had the highest population density in the entire country. For millions of new arrivals to America, the Lower East Side was their first home after a long sea voyage, medical inspection, and registration on Ellis Island. Because of its popularity as a landing spot, the area became overwhelmed. More apartments were needed quickly, flimsy wooden structures gave way to "old-law tenements," poorly constructed, squalid structures built almost fully on the standard city plot of 25-by-100 feet. Without provisions for airflow, or interior windows for cross ventilation, diseases like tuberculosis, cholera and yellow fever ran rampant. As many as five families crammed into tiny two-room apartments, some sleeping in shifts; nighttime workers would slumber in the same beds that the day shift workers used, others slept on floors or shared sofas. Indoor plumbing didn't become widely used until the very end of the 1890s; one hundred people might share a few grimy outhouses in the back alleyways. Tenement dwellers would also use chamber pots inside the apartments and carry them downstairs to empty later. The collection of the human waste called "night soil" was done by men on horse carts, who would collect and transport it in the wee hours, sometimes just dumping it into vacant lots, or off a nearby dock into the river. Water for cooking was retrieved from a faucet in the alley and had to be lugged back upstairs. The hordes of immigrants that settled here made living conditions untenable. There was a call to action by numerous reformers, including Jacob Riis, who used his photographs and reportage to show the world the horrid conditions that existed, and to make a plea for better sanitation, education and building laws. Gradually laws changed, many more schools and public baths were built by the city and conditions improved. "New Law tenements," slightly improved versions of the "old laws," offered airshafts and more air circulation. As the subway system expanded, many immigrants were able to move out of the area to find better neighborhoods, further afield; but there have always been new immigrants to take their place, including Puerto Ricans, and Chinese. One hundred years later, the Lower East Side has evolved into a coveted area for living and play, especially for the young. Innumerable bars, restaurants, and music venues keep the sidewalks buzzing all night. Some old stalwarts such as Russ and Daughters' Appetizers, Katz's Deli and Yonah Schimmel's Knish have managed to weather the changes (and were smart enough to own their own real estate) and continue to run their businesses today.

MANHATTAN

MIDTOWN EAST

This dense, crowded neighborhood is the setting for numerous landmarks, including the original GE building on Lexington Avenue, an Art Deco treasure designed by Cross and Cross, with a pinnacle embellished with carved lightning bolts. To the south is the twin towered Waldorf Astoria by Schutlze and Weaver, and, across from that, the Byzantine Revival–style St. Bartholomew Church, by Bertram Goodhue. Recently rezoned under Mayor Bloomberg, whose administration felt that Midtown East's older office buildings could not compete with other international cities for new tenants, the neighborhood is in the process of major changes. Many already large buildings are being replaced by mammoth structures; case in point is the mid-century masterpiece, Union Carbine building, designed by Gordon Buntshaft of SOM, and finished in 1960. Now owned by JP Morgan Chase, preservations were unsuccessful in their attempts to landmark it, and at 708 feet, it will become the tallest building in the world to be intentionally demolished, overtaking the record holder Singer Building that was dismantled in 1968. Its replacement will be a 1,322-foot tower designed by Foster and Associates. On 42nd Street, two 20-story fully functional, Beaux Arts office buildings were demolished to make way for One Vanderbilt, a tower that will be fourth tallest in the city, at 1301 feet at roof level. With a daily average of 200,000 pedestrians, the already packed Midtown East streets and subway entries will only become more crowded in the near future.

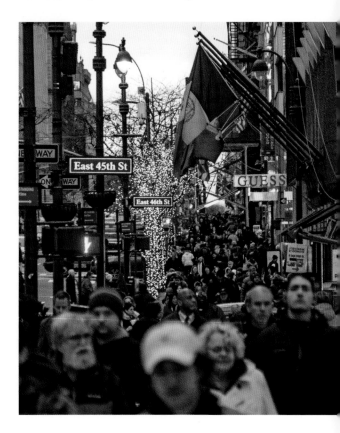

opposite: The ornate Art Deco crown of the GE Building is an homage to modern electricity and the future
right: Holiday crowds looking up Fifth Avenue

Next spread:

page 148 (clockwise from top): The square block Bloomingdale's is a longtime shopping mecca; night view; Midtown office buildings at night, Citibank tower in the background
page 149: When completed in 1958, Mies Van der Rohe's iconic Seagram's Building immediately became the standard for elegantly proportioned modernist skyscrapers

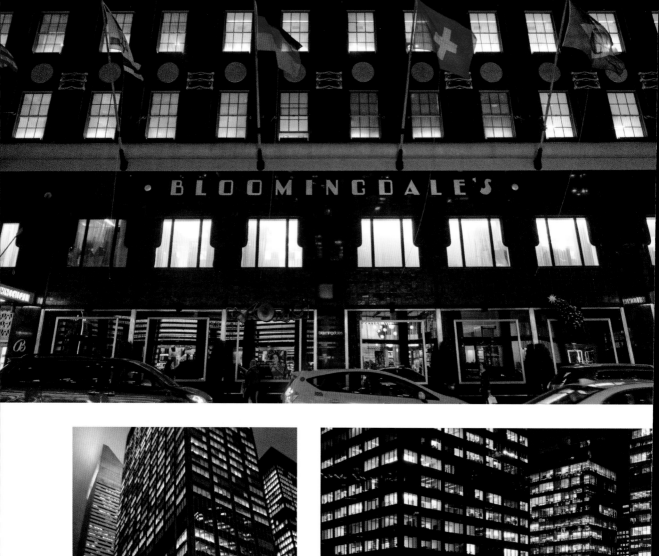

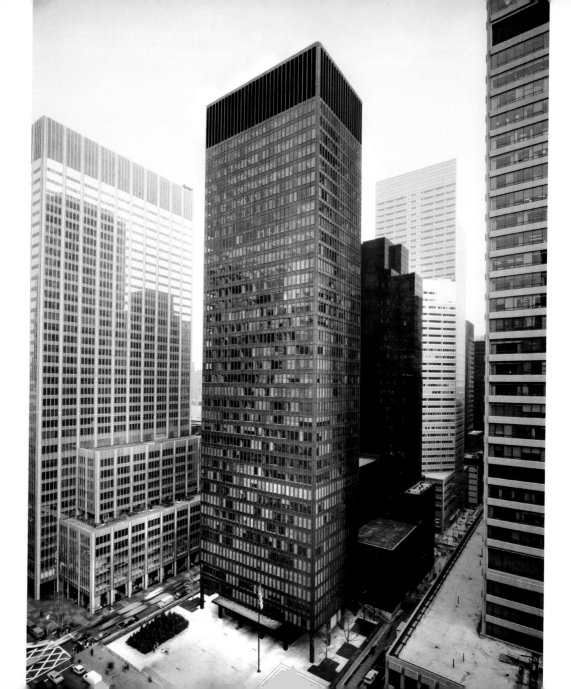

MIDTOWN: GRAND CENTRAL TERMINAL

Located on the site of today's Grand Central was Grand Central Depot, a massive, stone Second Empire–style structure, designed by John Snook. At the time of its completion in 1871, with glass train sheds running north to 48th Street, it was largest train station in the world, shared by the New Haven, Hudson River and the Harlem Railroads. Financed by Cornelius Vanderbilt, who had stakes in all three railroads, he was warned by his reluctant backers that the depot was too far from the center of New York, but he was undaunted. At the start of operations, the tracks ran at street level running north, but during the first 12 days, seven people died, run over by trains. A plan was instituted to make a cut below street level and bury the tracks all the way to 96th Street. Serving over 11 million passengers a year by 1897, the depot reached capacity, and was greatly expanded. The newly revamped station opened in 1900, with much grander facades, and enlarged waiting rooms in the Neo-Renaissance style. Train traffic continued to increase, with steam locomotives running underneath Park Avenue, spewing great amounts of smoke and fumes. In 1902, a southbound locomotive ran through

signals obscured by the smoke in the tunnel, crashed and killed 15 people. Shortly after this horrific accident, the state banned all steam trains from Manhattan, and a plan for electrifying trains was implemented. Once trains were electrified and the smoke was gone, the railroads, (now unified as New York Central), also created street crossings at the intersections along Fourth (Park) Avenue, increasing value to the real estate they happened to already own. In 1903, a proposal was put forth to totally rebuild the station again, in part to expand, and also to compete with the anticipated Penn Station across town, planned by New York Central's archrival, the Pennsylvania Railroad. The new Grand Central Terminal was heralded as a Beaux-Art masterpiece, and along with train electrification, the area was transformed into the hub of American capitalism. The next 20 years saw a building boom, within the "Terminal City" area including the Commodore, Biltmore and Roosevelt hotels and the classic Art Deco Chrysler Building, with its iconic stainless-steel spire, and the Chanin Building, featuring an Art Moderne frieze of fish and birds by the sculptor Rene Paul Chambellan.

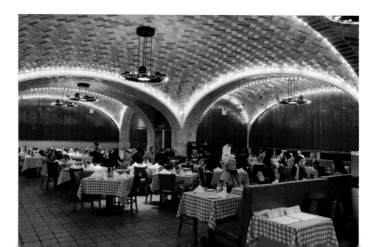

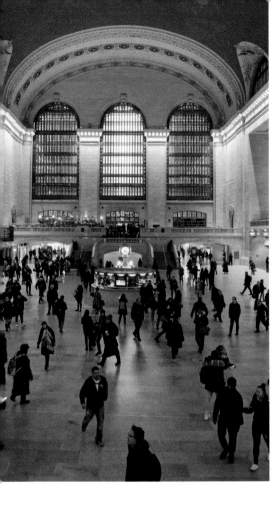

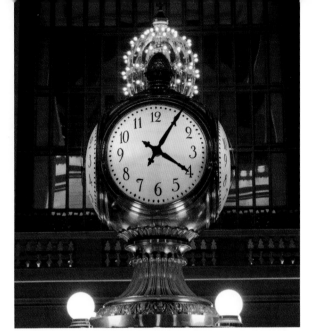

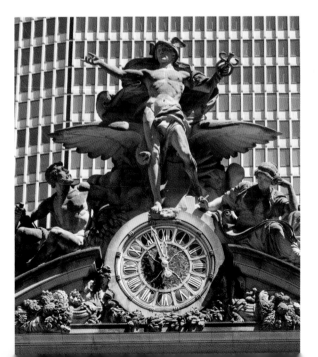

opposite: Underneath the main hall of Grand Central since the opening of the station in 1913, the arched Guastavino tiled ceiling of the Oyster Bar, which has long served delicious raw and cooked seafood

this page (clockwise from left): Commuters do a sophisticated ballet to cross the awe-aspiring main hall; the four-sided clock over the information booth; Mercury holds court over the pediment and stained glass Tiffany clock of the main terminal

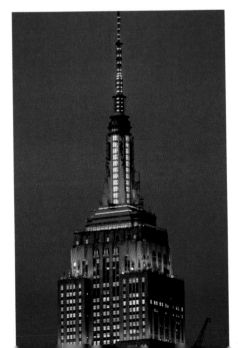

MIDTOWN: HERALD SQUARE

The neighborhood is named for the *New York Herald*, which once had newsrooms and presses at the intersection of Broadway and Sixth Avenue. The three-story Italian Palazzo–style building was designed by Stanford White, completed in 1908 and quickly demolished in 1921. It was a unique building that featured 26 four-foot bronze owl sculptures (meant to symbolize wisdom) above the cornice, and large windows on the ground floor to allow passersby to see the printing presses run. These days, the area is frenetic with great flows of office workers, shoppers, commuters and tourists. Herald Square (or Midtown South) is at the crossroads of many subway lines, and Penn Station, the place one finds Long Island Railroad commuter trains and Amtrak service to all points in the United States. Shoppers will find ample retail options, including the flagship Macy's, which bills itself as the "Largest Store in the World." The area was once home to many other department stores, including Ohrbach's, EJ Korvettes, B. Altman and Gimbels, which have all closed their doors. One cannot consider the district without mentioning the iconic Empire State Building designed by Shreve, Harmon and Lamb. Built in 1930, in a classic Art Deco style, it was once referred to as the "Empty State Building," as it opened shortly after the start of the Great Depression and had difficulty attracting tenants for many years. Its spire, now converted to LEDs, can be seen in a 30-mile radius, and is lit in various color combinations to mark occasions like Christmas, July Fourth, St. Patrick's Day, sports team championships,

and Gay Pride Day. The Empire State was the tallest building in the world until it was surpassed by the World Trade Center towers in 1970 and stood unopposed in its immediate neighborhood, but has now been jostled by newer towers that seem to encircle and crowd it for attention.

MANHATTAN

MIDTOWN: TIMES SQUARE

Visited by over 40 million people annually, the convergence of Broadway and Seventh Avenue has been called at various times the "crossroads of the world," "great white way," or "center of the world." Once known as Longacre Square, it was notable as a neighborhood with the horse carriage industry, prostitution and rampant crime. In the 1880s, new gas lighting was installed, and theaters began relocating to the square from points downtown. By the 1890s, it became a true theater district. In 1904, its name was changed to Times Square, after the building of the 25-story New York Times Tower on a narrow, triangular plot between 42nd and 43 streets. Within months of the Times Tower completion, the first electrified sign went up on 46th Street, marking the beginning of the tradition of using large illuminated outdoor signage for advertisements. The Times tower (no longer owned by the *New York Times*), became and remains the location of the actual New Year's ball drop, where up to a million people gather in the square below, braving the cold to bear witness to the changing of the calendar. In 1928, the *Times*

installed its famous news ticker, which still announces important news events to the crowds below. Times Square also had notable hotels, including the Hotel Astor with its famous outdoor rooftop ballroom and garden. The city's overall downfall in the '60s and '70s brought in new businesses, including low-end electronic shops, fast food joints and live sex shows. Prostitution and drug use dominated the street scene. In the late '80s, various plans from the city and local real estate interests were presented, resulting in a near total redevelopment, which added new office skyscrapers. The Disney Company followed, by renovating the historic, but decrepit Art Nouveau style New Amsterdam Theater to show the hit live-show *The Lion King*. Numerous new hotels, theaters, and attractions followed their lead, and by the mid-'90s, the area was transformed from seedy to glitzy, crammed with tourists. Still known as the theater district, the streets around Times Square are thriving, packed with huge restaurants, live theater venues, glaring signs (that now use even brighter LEDs), and sidewalks that are so crowded as to be near impassable.

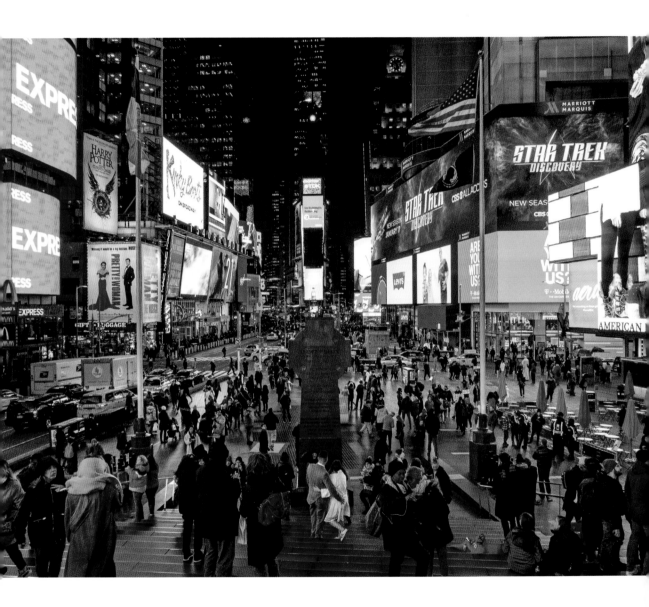

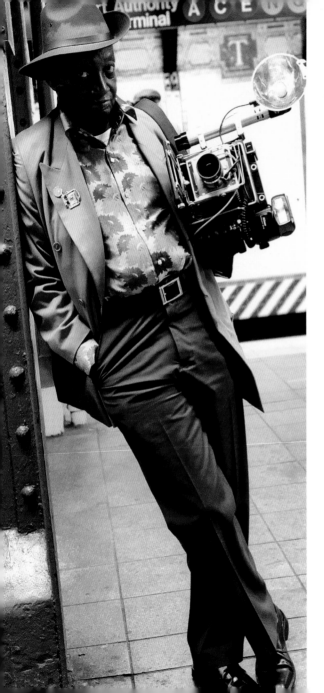

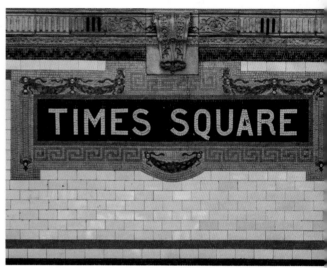

Previous spread:
page 154: Commuters pass under a Roy Lichtenstein mural in Times Square station
page 155 (clockwise from upper left): Bowlmor Lanes neon; Marriot Hotel open lobby with exposed elevator core; Shubert Theater marquee; Reuters and Paramount buildings

This spread:
opposite: Duffy Square is a popular gathering spot for tourists and New Yorkers alike
this page (left to right): Louis Mendes, named by the *New Yorker* "NYC's Most Classic Street Photographer"; Original Heins and LaFarge station mosaic from the first subway contract completed in 1903

MANHATTAN

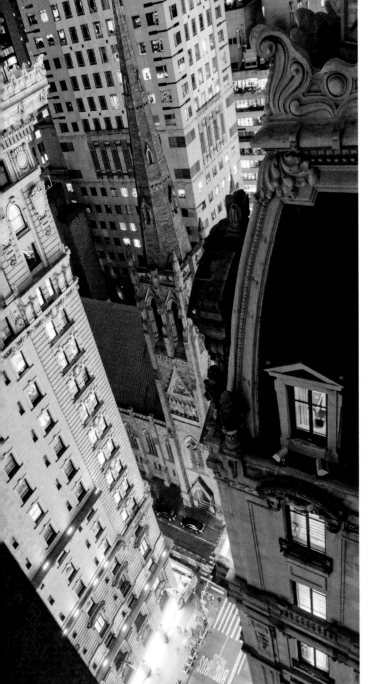

MIDTOWN: PLAZA/CENTRAL PARK SOUTH

Running three long avenue blocks across the southern edge of Central Park, the fine apartment buildings and hotels on Central Park South provide some of the grandest views and priciest real estate in the city. Crossing the street to the park, one mostly finds squirrels, pigeons, sparrows, and an occasional Mandarin duck, who in fact pay no rent at all. Central Park South is sandwiched by Grand Army Plaza to the east and Columbus Circle to the west. Grand Army Plaza features the Pulitzer fountain with the Goddess of abundance, Pomona, and the gold leafed statue of Union General William Tecumseh Sherman charging on horseback. Columbus Circle is a wide circular drive, bustling with cars and buses and fountains surrounding a 70-foot column dedicated to the explorer. In between, we find important buildings like the Plaza Hotel, built in 1907, offering both a high-end hotel and condos. Continuing west, we pass the St. Moritz Hotel, The Gainsborough studio building, with its huge double height windows and 18-foot ceilings, the Essex House, and the Art Deco 240 Central Park South. The recent newcomer, 220 Central Park South, towers over the park, and contains some of the most expensive homes in the world, topping out with the $238 million sale of four floors to hedge fund manager Ken Griffin. Two blocks to the south are the new mammoth stalagmite "supertalls," including the 1550-foot Central Park Tower at 217 West 57th, which houses the city's first Nordstroms department store; ShoP's 111 West 57 Street, a thin sliver built over the old Steinway Hall showroom, at 1,428 feet tall and barely 60-feet wide; and One57, a multicolored glass tower at a mere 1,005 feet, that became notorious for providing a separate entrance called the "poor door" for its rent subsidized tenants.

opposite (clockwise from left): Looking down onto the Peninsula Hotel, Fifth Avenue Presbyterian Church, and the St. Regis Hotel; one of Bergdorf Goodman's always stunning holiday windows; Central Park Tower under construction—when completed it will be the tallest residential building in the world at 1,550 feet
right: Ornate Beaux-Arts architectural details of the Peninsula Hotel

MIDTOWN WEST

The neighborhood defined as Midtown West, 42nd to 57th streets, west of Fifth Avenue to Eighth Avenue, was once rolling green meadows at the time of the Dutch settlement. In the late 1700s, the physician David Hosack bought 20 acres of land (the site of today's Rockefeller Center), and built America's first botanical garden. Opened in 1801 as Elgin Gardens, its main purpose was to cultivate native plants and tree specimens that were used as medical

cures at a time predating chemically manufactured drugs. Thomas Jefferson and others donated rare seeds and trees to Dr. Hosack, who was also a prominent doctor, unsuccessfully attending to Alexander Hamilton's wounds after his gun duel with Aaron Burr. The garden was contained by a 7-foot stone wall, and had two large glass greenhouses for plant cultivation. Unfortunately, for lack of funds, Dr. Hosack was unable to run the garden indefinitely, and sold it to New York State in 1814. The state transferred the land to the Kings College (later Columbia), who attempted to maintain the garden. Development around the garden began in the 1840s, as many African-American workers constructing the Croton Reservoir (now Bryant Park) moved to the area. A huge stream of Irish and German immigration followed in the 1850s, and many of those newcomers took jobs at the docks, warehouses, factories and slaughterhouses that lined the waterfront and side streets. Under Columbia's stewardship, the garden fell into misuse and was developed into boarding houses and speakeasies. In 1928, Columbia leased the land to John D. Rockefeller for $3.5 million per year until 1952. Rockefeller in turn developed an art deco city within a city, modestly called Rockefeller Center. The centerpiece is "30 Rock," a soaring 850-foot skyscraper with streamlined setbacks and observation deck, surrounded by smaller, analogous office buildings. Today Rockefeller Center is still a thriving center of entertainment, including NBC Universal TV studios and the daily broadcasts of the *Today* and *Tonight* shows. Radio City Music Hall, a shrine to Art Deco since 1932, has been home to the high stepping Rockettes, the annual Christmas show, as well as major headliners throughout the year. Midtown West is also the location of Carnegie Hall, City Center and the Art Students league. Looking North on Sixth Avenue, one sees a canyon of tall skyscrapers that leads directly to Central Park.

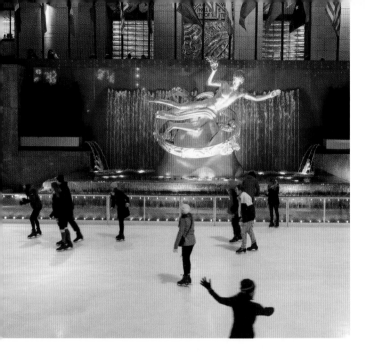

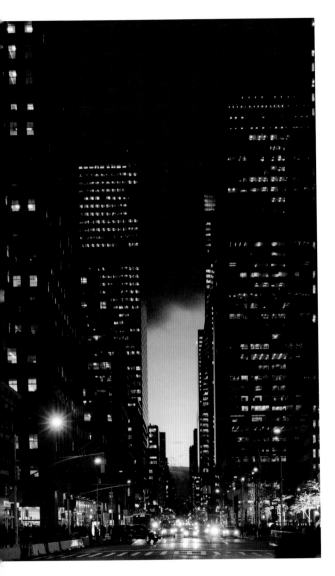

Previous spread:
page 160: A harmonious grouping of rooftop water tanks
page 161 (clockwise from upper left): Paul Manship's Prometheus sculpture looks over skaters at Rockefeller Center; "30 Rock," the centerpiece of the massive Art Deco Rockefeller Center complex; New York Public Library detail; posing by the McGraw Hill fountain

this page (left to right): looking south on Sixth Avenue; Lee Lawrie's imposing Atlas sculpture stands 45 feet at the entry of 45 Rockefeller Plaza
opposite: When Radio City Music Hall opened in 1932, it was the largest auditorium in the world, providing seating for 5,960 people

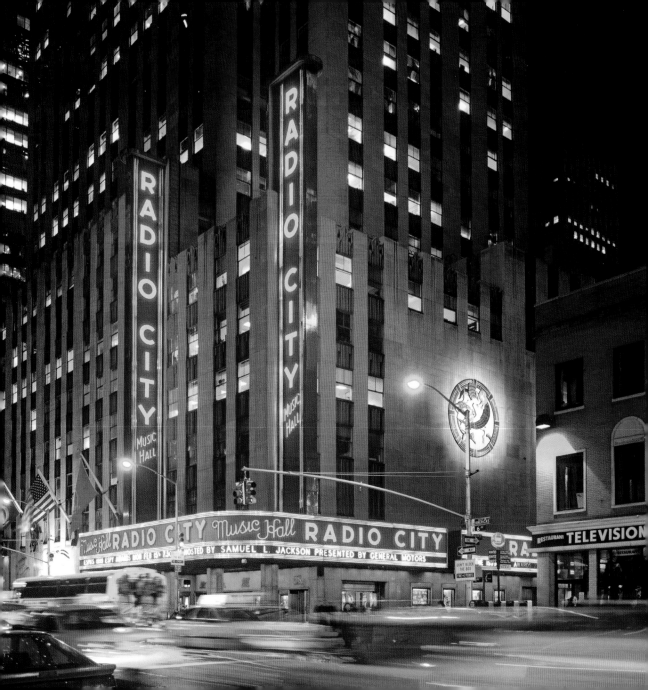

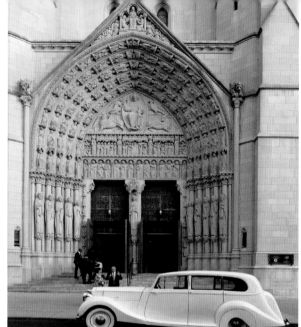

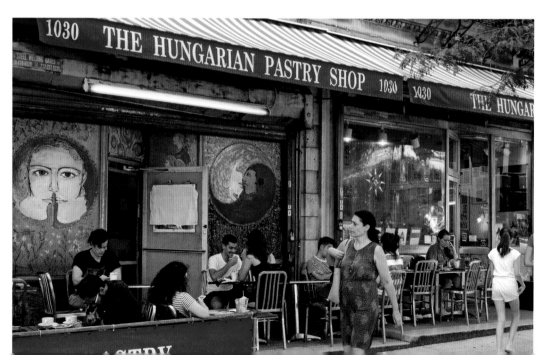

MORNINGSIDE HEIGHTS/
COLUMBIA UNIVERSITY

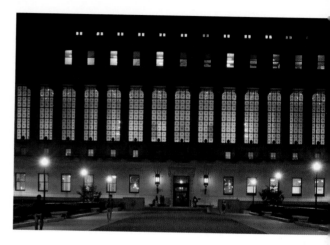

opposite (clockwise from upper left): The 1985 *Peace Fountain* by Greg Wyatt outside of Cathedral of St. John the Divine; a white Rolls Royce waits outside Riverside Church to take newlyweds to their honeymoon; The Hungarian Pastry shop, a well-known hangout for Columbia students
right: Butler Library is Columbia's largest library, containing over two million volumes

Comprising the blocks between 110th to 125th streets, Morningside Park to the east, Riverside Park to the West, the neighborhood was once home to the first facility for the mentally ill in New York State. The Bloomingdale Insane Asylum operated from 1821 until 1892; it was discredited for its brutal treatment of its patients. The asylum grounds were on 26 acres around 116th Street, roughly the footprint of today's Columbia University campus. More than half of Morningside Heights is filled with facilities for education, including Columbia, Barnard and Teachers College. To the north are Union Theological Seminary, Mannes School of Music and the Jewish Theological Seminary. The surrounding blocks contain an abundance of stately 12- to 15-story, prewar buildings, many owned by Columbia for student and

teacher housing. Anchoring the neighborhood on either end are two grand religious structures. To the west, Riverside Church, modeled after the thirteenth-century Chartes Cathedral, towers over Riverside Drive, the bell tower holding the largest tuned bell in the world of 20 tons. On Amsterdam Avenue sits the massive Cathedral of St. John the Divine, which began construction in 1892 in a mix of Byzantine and Gothic Revival styles. Although only three quarters completed, it is still the fifth largest church in the world. St John's is the site of sermons, concerts and one of the largest blessings of the animals honoring St. Frances of Assisi. Over the years, the blessed have included elephants, kangaroos, foxes, possums, tortoises, camels, and, of course, more than a few cats and dogs.

NOHO

NoHo, which encompasses the blocks north of Houston Street to Astor Place, east of Broadway to the Bowery, sits in the shadow of SoHo, its busier, more prominent cousin to the south. In 1805, the fourth incarnation of Vauxhall Gardens and Amusement Park was built on farmland on the west side of Lafayette Street. Today, the cobblestone streets are lined with cast-iron, marble, limestone and brick building facades. One can observe over 125 landmarked buildings that present a catalog of 1850–1910s commercial architecture, a time when NoHo was New York City's retail center. Bond Street, a microcosm of the neighborhood, was once an elegant residential street, home to regal Greek-Revival townhomes, but lost its luster in the 1900s, when townhouses were replaced by garages and warehouses. In the past twenty years the streetscape has changed again, with modern condominiums designed by such blue-chip architects as Herzog and de Meuron, Annabelle Selldorf, and Deborah Berke.

Other architectural standouts throughout the area include Louis Sullivan's Bayard-Conduit building, and Colonnade Row, originally nine Greek-Revival buildings constructed in the 1830s, on the site of the old Vauxhall Gardens. Today, but four remain in rather decrepit condition, with columns being held together with metal netting. Across the street stands the Public Theater, originally built by John Jay Astor as a public library, then purchased in 1920 by the Hebrew Immigrant Aid society. In 1965, the building was taken over by Joseph Papp and his New York Shakespeare Festival, using funds from New York City. Since opening, it has been the site of countless stage and musical performances in its five theaters. Many shows that began at the Public went on to Broadway for successful runs, including *Hair* and *Hamilton*. The neighborhood has also been home to many artists, including Chuck Close, Jean-Michel Basquiat, Robert Mapplethorpe, Keith Haring and Robert Rauschenberg.

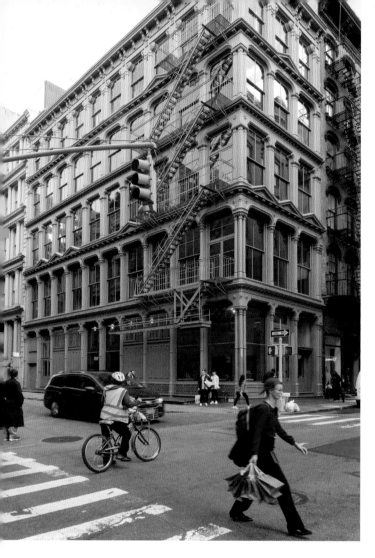

this page (clockwise from left): Cast-iron loft building on Spring Street that was once the home and studio of sculptor Donald Judd; late afternoon light on brick loft building; fresh breads in the window of Balthazar on Spring Street

SOHO

Notorious in the 1950s as "Hells Hundred Acres" for its glut of sweatshops and brothels, SoHo is home to possibly the finest collection of cast iron industrial architecture in the world. Because of its poor reputation, the entire neighborhood was nearly leveled by Robert Moses' ambitious plan to run an elevated expressway across Broome Street to connect the Holland Tunnel to the Williamsburg and Manhattan bridges. Thanks to Jane Jacobs and other urban activists, the plan was finally quashed, and SoHo remained intact. In 1644, the first freed Blacks settled here after winning their freedom from the Dutch and continued farming alongside white farmers throughout the eighteenth century. In the early 1800s, the hilly terrain was leveled to fill in the foul smelling swamp that ran across Canal Street. Soho promptly became ripe for development, by 1825 the neighborhood was filled with red brick, Georgian-style houses, and was the most densely settled part of the city. An incursion of businesses and retail establishments, including Tiffany's and Lord & Taylor, hotels, casinos, brothels and music halls filled the neighborhood. In the 1860s, employing newly developed cast iron technology, many elaborately embellished buildings were commissioned, utilizing this inexpensive, easy to manufacture material. The mostly 5-story buildings, with tall ceilings and large windows, were used as ground floor showrooms for china, lace, furs and tobacco, and manufacturing and storage on the upper floors. As the finer businesses moved to new quarters further uptown, SoHo went into decline throughout the twentieth century. The 1960s brought artists attracted to the cheap empty loft spaces above. The first gallery, named OK Harris, was opened in 1969, on West Broadway, by art dealer Ivan Karp and others soon followed, utilizing the large storefronts at street level. Today, SoHo is a teeming commercial district, with nearly every international clothing chain represented in the roomy street level stores and multi-million-dollar lofts above.

TRIBECA

Actually shaped like a trapezoid, the "Triangle Below Canal Street" was a designation coined by enterprising real estate agents in the 1970s to define a once dormant and forsaken industrial zone. Tribeca is packed with marvelous nineteenth-century manufacturing and warehouse buildings fabricated mostly of brick and stone, with some examples of cast iron thrown into the mix. Starting in the 1970s, many of the dairy businesses left the area to move to more modern facilities at the Hunts Point market in the Bronx. Gradually artists and performers took over the large warehouse spaces, which were ideal for creating art. The neighborhood has morphed into one of the most expensive in the city, with spacious lofts in converted landmarked buildings, excellent schools, restaurants, walking proximity to the financial district and relative safety. Historically, the terrain in lower Manhattan transformed from thick forest to farmlands once the Dutch settled in the early seventeenth century. In 1705, Queen Anne of England deeded much of the land to Trinity Church, who even today retain much of their holdings. In 1807, Trinity built the magnificent 214-foot-tall St. John's Chapel on Varick Street. With a portico of red sandstone and a tower fabricated of oak, the new church faced a park built to encourage residential development. During the 1880s, Tribeca evolved, with numerous loft buildings erected for the storage and exchange of butter, cheese and eggs. By the twentieth century, the neighborhood became mostly commercial, so the church decided to realize the maximum value of its land, selling the parkland to the New York Central and Hudson River railroad to use as a freight yard. Many neighbors and the city fought to save the church, but Trinity demolished it. Today the site of that church is the entry to the Holland Tunnel.

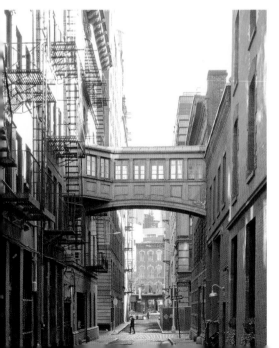

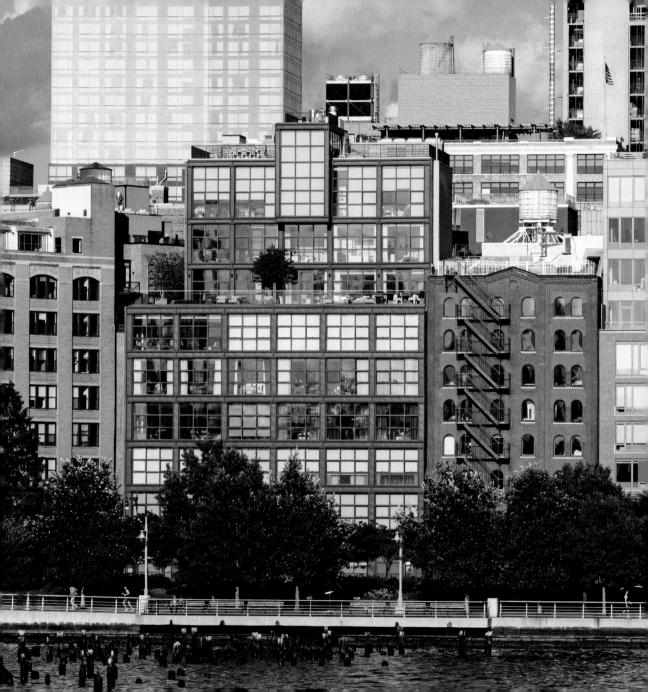

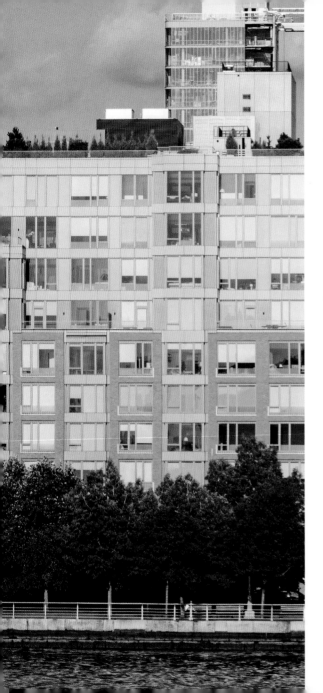

Previous spread:

page 170: Pioneering neighborhood stalwart Odeon has been
serving excellent food in an understated, elegant setting since 1980
page 171 (clockwise from upper left): A stylized Art Deco eagle
graces the corner precipice of the Church Street post office; the
original clock from wholesale shoe maker Nathaniel Fisher & Co.,
which has been a fixture on the street since 1845; Art Deco bas
relief by Wheeler Williams from 1938, depicting a Native American
pointing his bow toward the heavens, is the centerpiece of the
Canal Street Post Office; just two blocks long, Staple Street is
notable for its unusual sky-bridge, which once joined buildings that
were part of New York Hospital

this spread (left to right): Row of the old and new, buildings on
West Street stand sentry over the Hudson River; Wood's cast-iron
Mercantile Building from 1865 on White Street is now luxury loft
residences

MANHATTAN

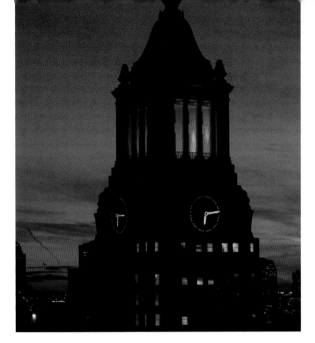

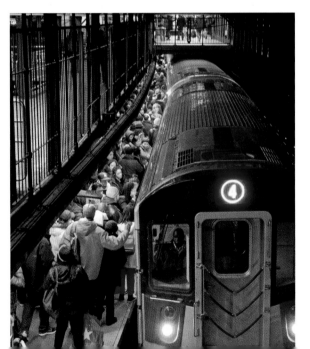

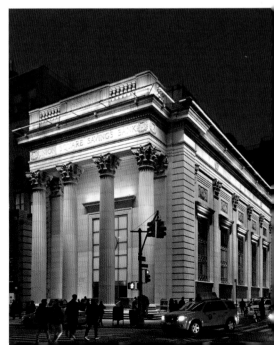

UNION SQUARE

In 1807, New York State determined to bring order to the future streets of Manhattan and created a commission to survey and draw up a grid plan for the land north of Houston Street, up to 155th Street in Washington Heights. Because the Bowery Road had to angle so severely at 14th Street to meet the Bloomingdale Road (later Broadway), it was decided to build a square at the union of the two streets, which was formerly a potter's field. The plot was first called Union Place, but, in 1832, the banker Samuel Ruggles (who would also develop the land around Gramercy Park) convinced the city to rename it Union Square and to enlarge the park to 17th Street to the north, and University Place to the West. Ruggles received leases for most of the surrounding lots and the city created a formal park, with pathways and a fountain, enclosing it with an iron picket fence. Historically, the square has been the gathering place for many political rallies. In 1861, the largest rally in United States history up to that time took place here, drawing in excess of 250,000 people protesting the invasion of Fort Sumter by the Confederate forces. The square continued to be a gathering place for parades, speeches and political rallies. In 1871, the city formulated a new park plan and hired Olmstead and Vaux for a redesign. The fountain, fences and hedges were removed, replaced by the planting of mature trees, widened paths and the installation of a review stand for public gatherings. 1882 brought the first Labor Day parade, and in 1894 President Grover Cleveland declared the day a national holiday. During 1928 to 1929, the park was demolished and totally redesigned again to make way for a new subway concourse below ground. Paths were straightened, new statuary installed, and a pavilion was added. 1976 brought the city's first greenmarket, which sold fresh produce four days a week from nearby farms to city dwellers. The market is always thronged with shoppers, attracting over 350,000 people on a typical day. In the 1980s the park and immediate neighborhood had deteriorated into a drug infested, low-end retail destination where drugs were used openly. The park was rethought anew, and the city decided to lower the entire park so that sightlines were improved for law enforcement. Presently, the neighborhood has thrived, with an abundance of new development, restaurants and stores. Union Square Park is still a favorite gathering place for a wide range of New Yorkers, from skateboarders to pensioners.

MANHATTAN

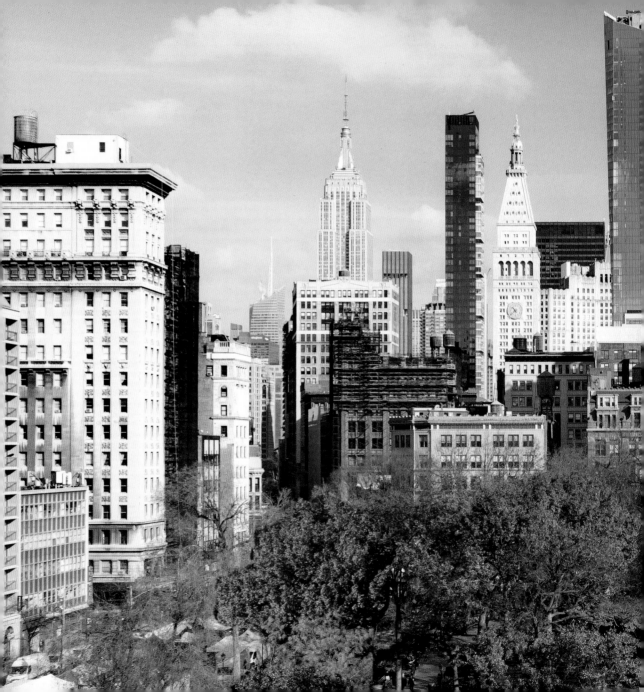

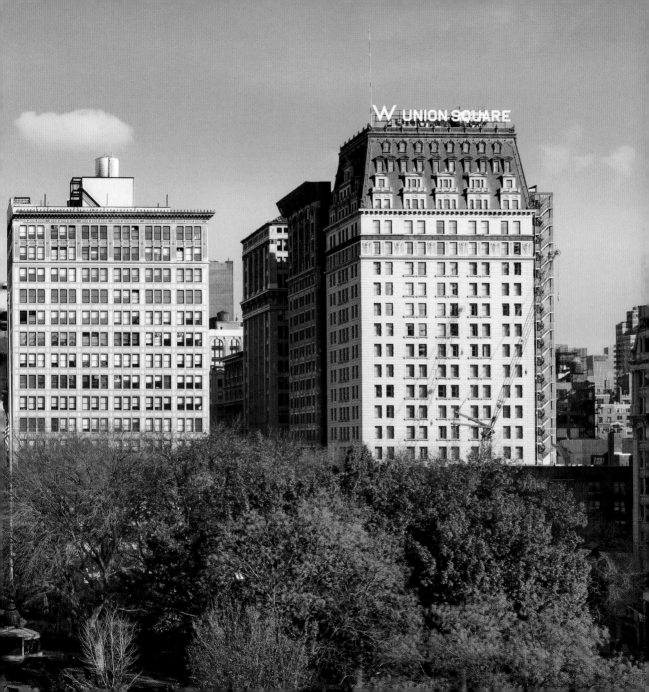

UPPER EAST SIDE

Originated on bluffs overlooking the East River, the terrain that makes up the eastern edge of the Upper East Side is thought to be former Lenape Indians fishing grounds. By the start of the nineteenth century, the area was mostly farms and forests. The years 1878 and 1879 brought more new train service, including the Third Avenue and Second Avenue elevated trains, respectively. This expansion of train service attracted immigrants from the Lower East Side. The eastern part of the neighborhood (mostly east of Lexington Avenue) became an enclave of Germans that became known as Yorkville. Many more Germans arrived after the General Slocum riverboat accident of 1904, which killed over 1,000 mostly women and children who were on an East Village Lutheran Church outing. The surviving community members desired to move on from the painful memories and start fresh on the Upper East Side. It remained a German and Eastern European stronghold until the 1960s, with a profusion of butcher shops, bakeries and restaurants to serve the community. Today there are but a few

establishments left, including the Schaller and Weber meat purveyor and the Heidelberg Restaurant on Second Avenue. The Upper East Side is really three distinct areas: Yorkville, Carnegie Hill and Lenox Hill. The northwestern part, considered Carnegie Hill, is more staid, with numerous old mansions along Fifth Avenue facing Central Park. Once called "millionaires' row," many of these mansions have been turned into museums and cultural centers, including the Frick Museum, the Whitney mansion (now home of cultural services of the French Embassy), and the Sinclair house at 79th and Fifth, (today the Ukrainian Institute of America). Farther up Fifth are the Carnegie mansion, (now the Cooper Hewitt Design Museum), and the Warburg mansion, (the Jewish Museum). This "Museum Mile," also features Frank Lloyd Wright's groundbreaking and iconic Guggenheim Museum and the massive Metropolitan Museum of Art, the fourth largest museum in the world. In its entirety, the Upper East Side has the highest concentration of wealth in the nation.

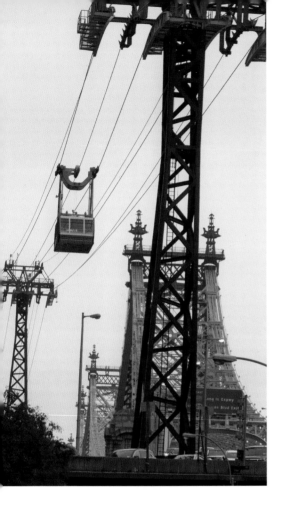

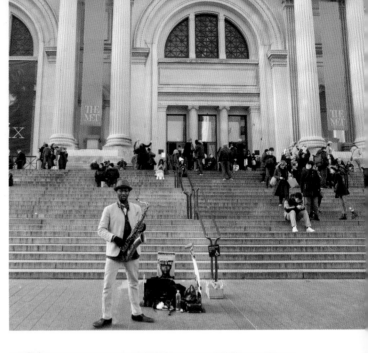

opposite: Celestial ceiling in the Albertine Bookstore
this page (clockwise from left): One of 21 aerial trams operating in North America, the Roosevelt Island tram, which connects to 2nd Avenue in Manhattan, spans the East River and is the only one used for commuters; pink-outfitted saxophonist entertains visitors to the Metropolitan Museum of Art; this long haired, chartreuse-double-breasted-suit-wearing gentleman is frequently seen shopping along Madison Avenue with his wife and beribboned dogs

MANHATTAN

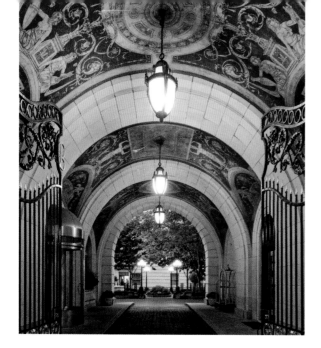

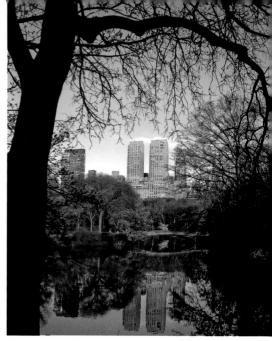

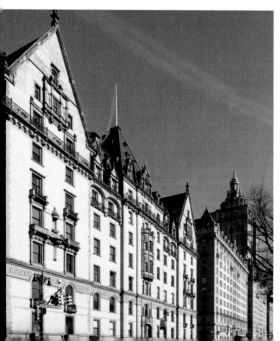

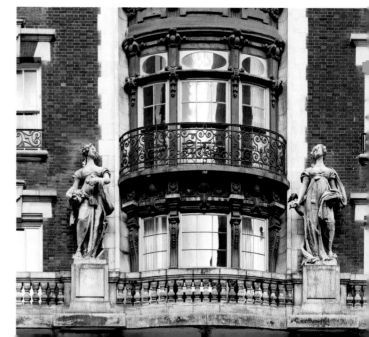

UPPER WEST SIDE

Residents of the Upper West Side are a fortunate lot, with an embarrassment of neighborhood riches. They are the beneficiaries of being bookended by two beautiful parks on its west and eastern edges (Central and Riverside), a vibrant commercial corridor bisecting the center (Broadway) and a plethora of cultural institutions to the south (Lincoln Center and Carnegie Hall). The Upper West Side continues to be an attractive neighborhood to live, a popular setting for families, single folk, retirees, dogs and almost everyone. In fact, it's so popular that overcrowding is a frequent complaint. It wasn't always so appealing, during the Great Depression, both the San Remo and Beresford apartment buildings were sold in total for $25,000, a price that wouldn't even buy a single storage unit today. In the 1960s and '70s crime was so bad, as depicted in the film, *Panic in Needle Park*, (with Al Pacino playing a drug addled petty thief), that people would refuse invitations to visit parties on Riverside Drive, townhouses were left vacant and tenants walked away from rambling, pre-War rent stabilized apartments. Bands of teenagers marauded through the streets, robbing people at will. After the Lenape Indians, the Dutch were the first to see the potential. The continuation of Bloomingdale Road, (later called the Grand Boulevard, now Broadway) in 1703 helped connect the area to Lower Manhattan. Throughout the 1700s, the territory was very rustic, with isolated country homes and large tobacco farms. Those few residents from that time would find it difficult to envision an area with over 100,000 people per square mile today. Planning for Central Park in the mid-1800s resulted in forced removal of the residents west of Fifth Avenue who were living in shanties on small farms. Once the park was developed to the designs of Olmstead and Vaux, things began moving forward. The first elevated line built in 1868 on Ninth Avenue (Columbus), by the West Side and Yonkers Patent Railway, brought new buildings. 1884 brought the city's first luxury apartments, called the Dakota,

opposite (clockwise from upper left): Entry portal to the Belnord Apartments; towers along Central Park West seen from the lake of Central Park; statuary adorn the Dorilton apartment building on Broadway; the Dakota apartment building has been the home of numerous luminaries including Leonard Bernstein, John Lennon and Judy Garland
above: View from beside the New-York Historical Society of Spiderman during the Macy's Thanksgiving Parade

Next spread:
pages 184-85: overlooking the Hudson at the 79th Street Boat Basin Café

because the area was still so remote that it was considered to be the great plains of New York City. The area languished somewhat after the depression, slowing redevelopment, which kept the scores of side streets with rows of townhouses intact. Many elegant landmarked residential buildings also remain, including the Ansonia (home to many musicians and opera singers), the full square block Apthorp and Belnord buildings, with their enclosed interior carriage courts, and the double-towered San Remo and Eldorado, both standing guard over Central Park.

WALL STREET / FINANCIAL DISTRICT

Perhaps the neighborhood that creates more monetary wealth than anywhere else in the world centers around Wall Street, in the Financial District. For much of its history, the area has continuously been a hub of commerce. When the Dutch set up their settlement in Lower Manhattan in the early 1600s, it wasn't to escape religious persecution or famine, but to seek opportunity and increase trade with their homeland. Over nearly four centuries, as much as things have changed, they have remained the same, as the Dutch trade in slaves, hemp and sugar has transmuted into trade in stocks, bonds and futures. As its name implies, a protective wall was built river to river by the Dutch West India Company to prevent disruptions to the machinations of money making from the native Manhattanites from the forests that still stood to the North. From these early beginnings, the neighborhood has developed from muddy streets with tiny wooden shacks used for trading goods, to four- or five-story stone commercial buildings and tangles of telegraph wires overhead. The telegraph wires and smaller buildings were removed as a building boom occurred in the 1920s with the surging of the stock market. The financial district grew to become a dark, man-made canyon of skyscrapers, filled with streams of workers in the day, devoid of humanity at night. The observer and writer on urban spaces, Jane Jacobs disapproved of business areas that were abandoned at night. She wrote, in *The Death and Life of Great American Cities*, "To see what is wrong, it is only necessary to observe the deathlike stillness that settles on the district after 5:30 and all day Saturday and Sunday." However, in the past 15 years, many of the older office buildings have been converted to residential use and there is now a more lively, 24-hour feel.

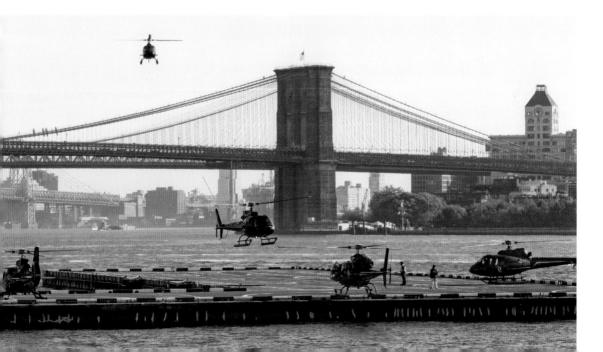

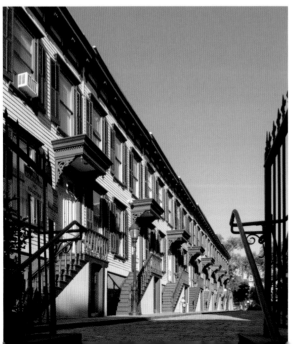

WASHINGTON HEIGHTS

opposite (clockwise from upper left): Terracotta ship prow on the former Audubon Ballroom—beginning life as the San Juan Theater in 1912, it became the infamous site where Malcolm X was assassinated in 1965; George Washington Bridge at dusk; take a staircase up from busy St. Nicolas Avenue, to the left of the 4 Angels Laundromat to discover this almost secret one block enclave of wooden homes set on a quiet cobblestone street *right:* Pigeons enjoy the ornate terracotta exterior of the Loew's 175th Street Theater, designed by Thomas Lamb in 1930—today called the United Palace, owned by the Christ United Church

Washington Heights permeated the public consciousness in Lin-Manuel Miranda's first Broadway hit *In the Heights*, a musical about a Dominican-American bodega owner who dreams of a better life. With the extension of the Broadway IRT line in the 1920s, the community developed into a densely settled neighborhood, its long streets between the avenues were predominately filled with chunky 6-story tenements and apartment buildings. Over the years, the Heights have been home to Irish, German Jews, Puerto Ricans and Dominicans. In 1765, British officer Roger Morris built a mansion high on a bluff overlooking the Harlem River, which remains the oldest private home in Manhattan. The mansion became headquarters for both the British and American armies during the Revolutionary War and is now open to the public as the Morris-Jumel Museum. In 1776, George Washington stood on the porch and watched the British burn much of the city to the south. After an important battle at Fort Washington that was a decisive British victory, the revolutionaries were forced to surrender Upper Manhattan. About eight miles from midtown, the Heights became a favorite place for wealthy New Yorkers to build country estates in the nineteenth century. The former John James Audubon estate stood near 155th Street and is memorialized today by Audubon Terrace. Trinity Church also expanded their downtown cemetery operations to 155th Street, across Broadway from a trio of cultural institutions that including the Hispanic Society of the Americas, with the world's largest collection of El Greco paintings.

WORLD TRADE CENTER

On May 2, 1968, the "Committee for a Reasonable World Trade Center," took out a large ad in the *New York Times* opposing the proposed size of the WTC, saying in effect that its vast height would constitute a threat to air traffic over Manhattan. The retouched photo in the ad shows an airliner about to strike a rendering of the North Tower! Behind the "committee" and the ad was Lawrence Wein, the owner of the Empire State Building whose self-serving interest in keeping the Empire State the tallest building in the world was obvious. The preliminary idea for the World Trade Center complex was discussed over lunch when David Rockefeller told Robert Moses of his plan to build a new Chase Manhattan Bank tower in downtown Manhattan to help revive the area's dormant economy. Moses felt the idea foolhardy unless Rockefeller could prevent other businesses from abandoning Lower Manhattan for Midtown. In 1957, Rockefeller proposed building a World Trade and Financial Center on the East Side of lower Manhattan, on the site of the Fulton Fish Market. By 1960, the Port Authority of NY and NJ became involved, advocating for the location on the west side of lower Manhattan. They also pushed forth the idea that only a public agency could handle the complicated logistics of building two huge 72-story buildings (as was the early plan). In 1964 the proposal moved forward, as the governor of New York (Nelson Rockefeller), promised the state would lease large swatches of space. The Port Authority released the plans by Minoru Yamasaki's design for larger, twin 110-story towers. After years of lawsuits

from commercial tenants who were to be forcefully evicted at the site, the case finally reached the Supreme Court, who declined to hear the arguments. Construction of the foundation began in 1967, the structural design called for the towers to withstand the crash of a Boeing 707 jet, which was the largest commercial airplane at the time. It was anticipated that a jet might lose its way in the fog, but not be the target of a terrorist attack with an airplane the size of a 747 loaded with thousands of gallons of jet fuel. The towers were completed in 1973 and for many years were mostly empty, as the city struggled to rebound from the financial crisis. By the mid-'80s the buildings were full, with many investment firms taking office space. The morning of September 11, 2001, was crisp and fresh, with clear deep blue skies. From my apartment in the East Village, I could hear the roar of a jet fly overhead at a very low elevation. I received a text from a friend with the news that a plane had hit the north tower. I immediately conjured up the photographs of the small plane that crashed into the Empire State Building in 1945, causing minor damage, with one secretary killed. I began walking downtown with my dogs to find people gathered on street corners listening to transistor radios, discussing the latest developments. As we drew closer, I could see smoke from the direction of the towers. I listened as people were talking more animatedly, as rumors began circulating. We paused at Worth Street and Church where we could see the burning towers in full view. Because of the pandemonium and constant emergency sirens, no one in my vicinity saw or heard the second jet fly into the south tower. Quietly observing the smoke pouring out of the gap in the north tower, without warning, I saw a sight that will be forever burned into my mind. First a rumbling sound, then the gradual collapse of the north tower, as if in slow motion, followed a split second later by the sound of collapse. A broiling black cloud started rolling up Church Street, people began running, as if

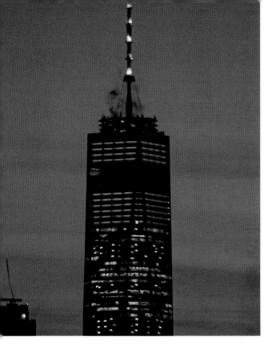

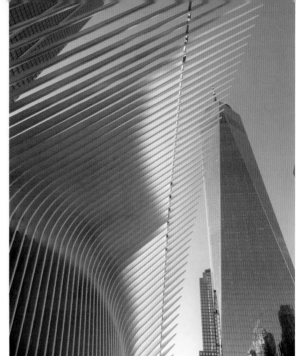

(clockwise from upper left): One World Trade Center, also called the "Freedom Tower," rises to the symbolic height of 1,776 feet; Santiago Calatrava's WTC Transportation Hub soars like the wings of the bird in the plaza; the *National September 11 Memorial Fountain* was built on the actual site of the destroyed towers, with a marble perimeter wall featuring the names of each victim of the attack

being chased by a tidal wave, looking over their shoulders in terror. Police waved for everyone to run. I was momentarily stunned and wondered: how could this enormous building just fall? Everyone in the crowd continued north to Houston Street, where we paused to see the second tower collapse. Everything grew still and silent, time seemed to stop. To the north were beautiful blue skies, to the south, black and grey debris moving in the air towards us. Screaming and crying permeated the crowd, but a surprising degree of order and camaraderie as well. Strangers looked each other in the eye, deeply, as if to say, we are alive.

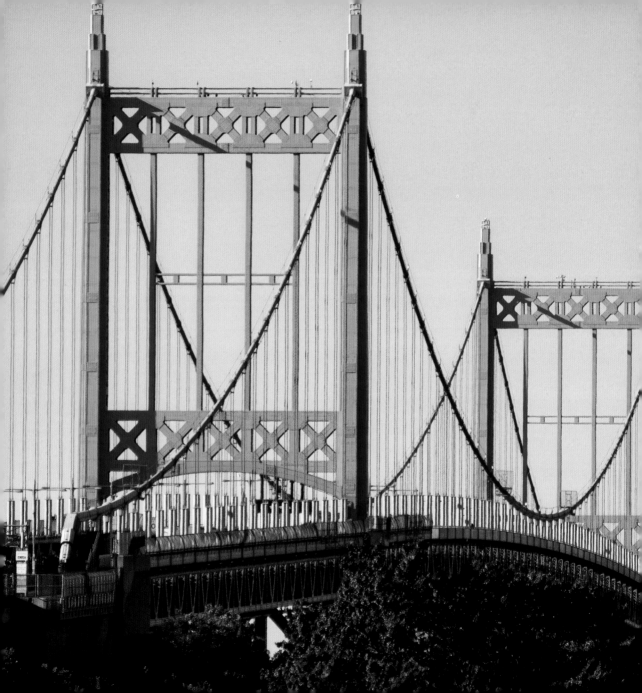

[QUEENS]

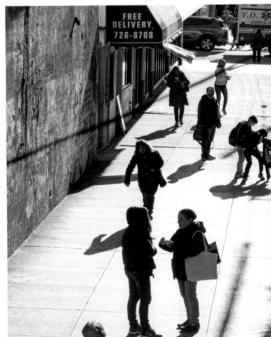

ASTORIA

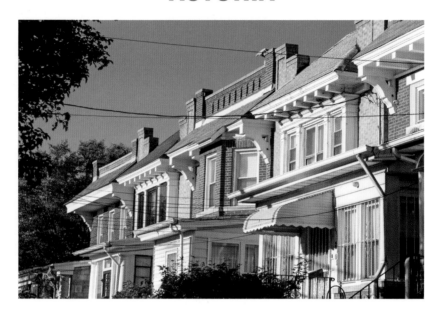

In 1798, a successful fur trader named Stephen Halsey founded a small community near the East River on terrain that would become Astoria. Halsey petitioned New York State to name the area after another, more famous fur trader named John Jay Astor. Because of its location on the East River, many wealthy New Yorkers built summer estates along 12th and 14th streets during the early 1800s. Access to water also attracted numerous industries, including Henry Steinway, who bought a large tract of land and built a piano factory and adjacent sawmill. Valuing his skilled craftspeople, Steinway also built a village of small brick homes, a school, church and library for his workers. The building of the elevated transit line reached Astoria in 1917, which spurred the development of small apartment buildings. In spite of the Depression, and thanks to the efforts of Robert Moses and the constant flow of money from the tolls, the Triborough Bridge was completed in 1936, cutting through the neighborhood and providing quicker car and truck access to Manhattan, the Bronx and points west and north. Astoria's quiet and safe streets have lured wave after wave of ethnic groups over the decades, including Irish, Italian, Greek, Czech, Chinese, Columbian, Brazilian, and Korean. In the 1990s, Astoria's population was over half Greek, which accounts for the many Greek restaurants and Greek Orthodox Churches.

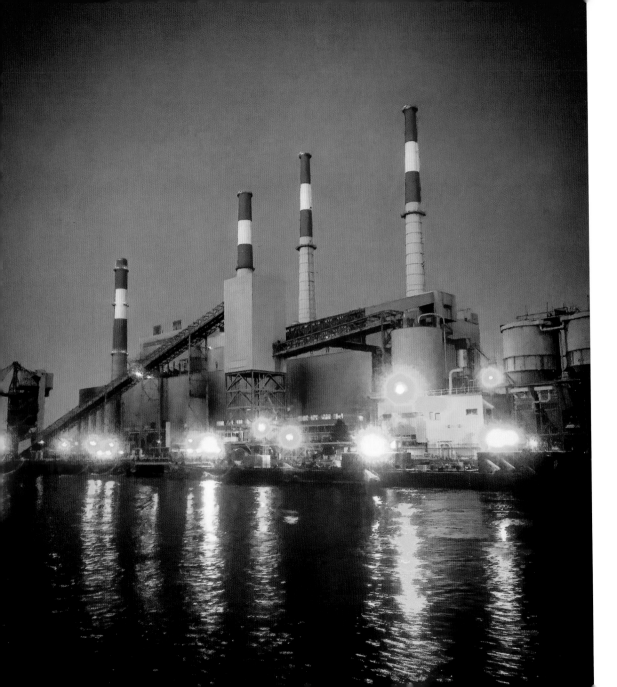

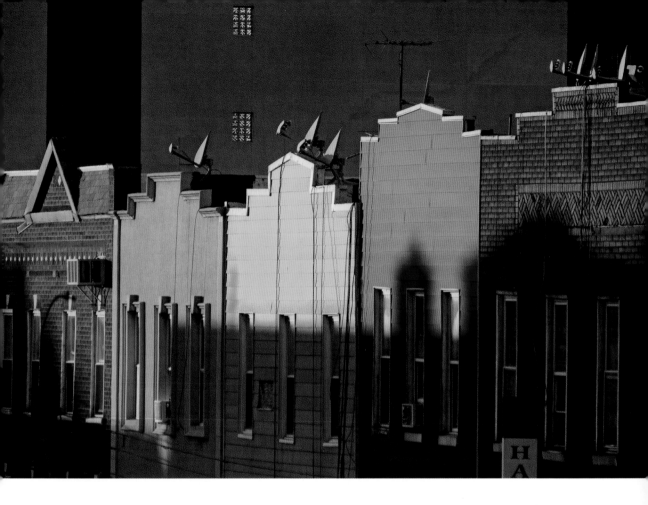

Previous spread:
page194 (clockwise from left): Technician inspects drying grand piano frames at the Steinway Piano Factory; piano strings being tested at the factory; people create shadows on 31st Street near Ditmars Boulevard
page 195: typical row houses on Ditmars Boulevard

This spread:
opposite: The Ravenswood Generating Station along the East River produces over 2,800 megawatts of electricity, fueled by both oil and natural gas
above: Brick and aluminum sided apartment buildings from the N and W elevated platform

QUEENS

ELMHURST

Initially settled by the Dutch as Middleburgh in 1652, the British renamed the area New Town, later simplifying it to Newtown. Once rich farmland, a found seedling sprouted into a tree; that tree fruited into what was to become a favorite colonial treat, the Newtown Pippin apple. Originally bred by Thomas Jefferson and George Washington, the locals planted more trees as its popularity grew, and orchards abounded. Later, Newtown was called Elmhurst, to avoid association with the noxious Newtown Creek. In 1896, the *New York Times* maintained that the neighborhood had "not a single elm," however the name stuck. Crisscrossed with three major commercial thoroughfares, Elmhurst features a consumer's paradise of options, big box department stores, fish markets, nail salons, Kung-fu

studios, etcetera. Roosevelt Avenue, Broadway and Queens Boulevard offer pretty much everything and anything to everyone. There are also assorted subway lines, including the 7, E, F, M and R, making Elmhurst incredibly convenient. Elmhurst is also quite diverse; as of 2013, the residents were 71-percent foreign-born, according a New York City census report. The diversity is reflected in the various houses of worship, which include Korean Evangelical, the Jain Center of America, St. Bartholomew Roman Catholic, Elmhurst Baptist, Bangladeshi Hindu, the Elmhurst Muslim Center, The Jewish Institute of Queens, Christian Testimony Church, and the Geeta Hindu Temple. Housing is somewhat affordable, composed of small wooden and brick row houses and mid-rise apartment buildings.

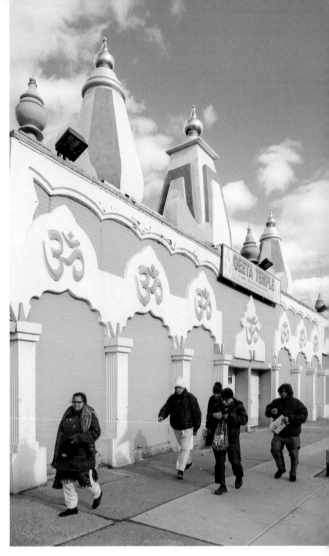

opposite: The White Castle on centrally located Queens Boulevard, is a long time go-to for cheap, square mini burgers
this page (clockwise from upper left): Shopping for broccoli at the New Golden Sparkling Supermarket on Broadway; worshippers leaving Geeta Temple on Corona Avenue; typical three-story row houses

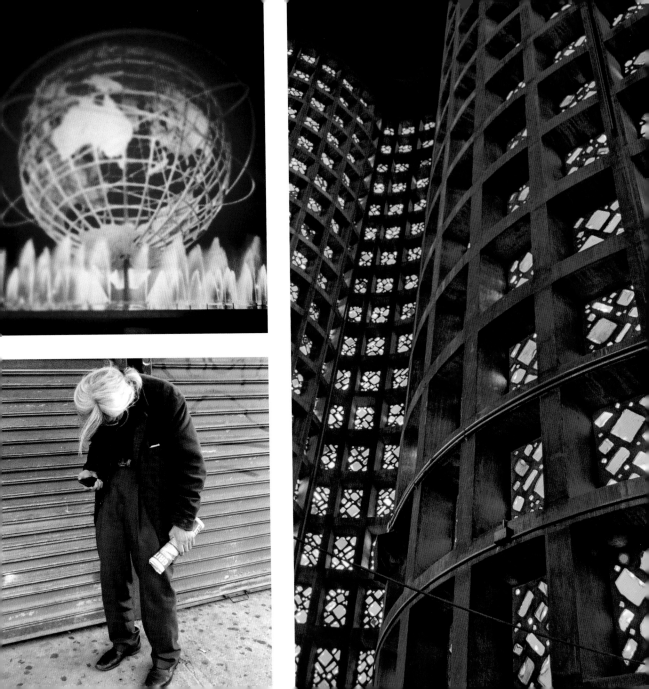

FLUSHING

From its roots as a Dutch settlement in 1645, Flushing has grown to become New York City's biggest Chinatown, with sidewalks bursting with food carts, massage chairs and harried pedestrians. Although somewhat distant from Midtown at the end of the #7 train, Flushing is known for its exploding real estate development, with over 3,000 new condo units being built in the past ten years, and a multiplicity of food options. A beacon for foodies is the New World Food Court, a cavernous hall located in the basement of a glassy mall that features thousands of food choices, a place that can be both thrilling and overwhelming. The approximately 30 different food vendors offer an adventurous eater Mayalsian, Chinese, Thai, Japanese and Korean options. Some of the myriad dishes include, Thai-style Buffalo chicken wings, spicy frog in octopus ink sauce, lamb fried noodles, Hong Kong–style egg puffs, mustard green and pumpkin congee, pink bubble tea and braised duck spleen. In the 1660s, a group of English colonists settled along side the Dutch seeking religious liberty and began holding Quaker meetings inside the home of John Bowne. Bowne was arrested in 1662 by Peter Stuyvesant, but appealed his arrest in Amsterdam directly to the Dutch West India Company. Although they overturned Bowne's arrest, the officers stated that Quakerism was still an "abominable religion," but the decree established the basis for religious tolerance in the colonies. This idea of freedom from persecution was also instituted in the writing of the United States Constitution, and Flushing is recognized as the spawning ground for religious freedom in America. Descendants of Bowne lived in the house until 1945, at which time it became a museum and later a New York City landmark.

Previous spread:
page 200 (clockwise from upper left): Now part of Flushing Meadows Corona Park, the stainless steel Unisphere is an abstract depiction of Earth, built as a centerpiece for the 1964–65 World's Fair; the undulating exterior walls of the Hall of Science, built for the World's Fair, is still in use as a science education center today; man stops to examine his cell phone near Main Street
page 201: Terracotta Art Deco building office building entry on Main Street

This spread:
page 202 (left to right): Shopper on Roosevelt Avenue; woman in shadow stands in store entry on Main Street
page 203: Crowds of shoppers along Main Street near Roosevelt Avenue

FOREST HILLS

Using great caution, we dash across a 12-lane speedway of cars and trucks that is Queens Boulevard, then turn down Continental Avenue. On sidewalks lively with shoppers, we pass Dunkin' Donuts, E-Vape, Banana Republic and Chase Bank, and we are momentarily plunged into a dark tunnel that runs under the Long Island Railroad tracks. As our eyes adjust, a ten-times life-size mural of the Ramones, neighborhood musical heroes in all their black leather glory, overwhelms us. Continuing, daylight reappears, and we are suddenly thrust into another world, another century. The busy commercial streets of Forest Hills are gone, and give way to Station Square, a Tudor Style town green, replete with arched shop arcades, pitched red tile roofs and an old clock tower. We believe we are amidst a 1920s English town, until abruptly a car passes by, shaking us back into reality. In 1906, the Cord Meyer Development Company (which still has offices in the community), purchased 600 acres and renamed it for the hilly, wooded terrain. Cord Meyer developed part of the area, and sold a section to Margaret Olivia Slocum Sage, who hired Fredrick Law Olmstead,

Jr. to outline the grounds. The architect Grosvenor Atterbury designed 1,500 mostly Tudor Style private homes and small six-story apartment buildings that constitute this leafy and quiet enclave, referred to as the "Garden Spot of Long Island." One of the earliest experiences in "cooperative" living, everything feels carefully planned and laid out, from the street signage, the carefully manicured gardens, the tennis club and the LIRR stop. The surrounding area of Forest Hills proper has more commercial streets including, Austin Street, 108th Street, and busy Queens Boulevard, with much larger apartment buildings, including many high-rises. The neighborhood has had large Italian and Jewish populations, but is evolving again, with an influx of many Asian families and Bukharin Jews. Once dubbed Whitepot, possibly as a reference to the clay vessels that were traded to the Native Americans for the land, Forest Hills became incorporated into Newtown (Elmhurst) as a tiny farming community. The six families grew hay, grains, vegetables and apples. By 1900, the *New York Times* reported the population was 30, mostly farmers, growing celery and potatoes.

left: Metal Arts and Crafts destination sign on Long Island Rail Road platform
opposite (clockwise from upper left): Metal Arts and Crafts streetlamp in Forest Hills Gardens; private home along Greenway North; the Tudor Style Forest Hills Inn Apartments; weathervane on church in the Gardens Community House

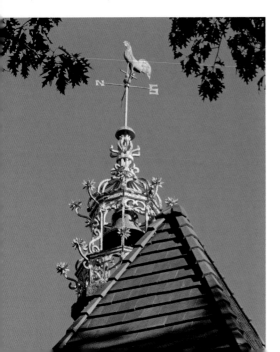

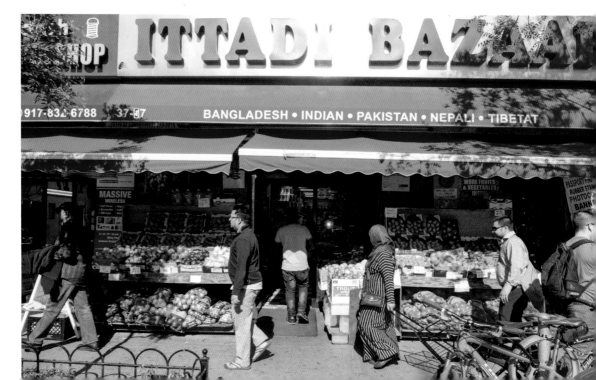

JACKSON HEIGHTS

Jackson Heights is a compact melting pot, within a greater melting pot, which is New York City itself. Stepping off the elevated train onto busy, Roosevelt Avenue, one is treated to a never-ending buffet of dining options. Under the shadow of the El, food trucks offer Mexican pozole and Columbian arepas. Crossing the street, one finds Nepalese Momo shops, and Peruvian sandwiches. Turning a corner reveals the Jackson Diner, a former greasy spoon that served American fare, now only cooking Indian centric cuisine, and presenting an $11.95 all-you-can-eat lunch. Jackson Heights is not only about food, as it provides quiet streets with lovely, if slightly homogenous six-story apartment buildings, many with central gardens. The similarity of housing stock is explained by the fact that many of the structures were built by the same developer. The Queensboro Corporation was a group of investors that formed in 1909 to purchase land and build housing in Trains Meadow, the former name of Jackson Heights. The company also built sidewalks, streets, sewer lines and electrical service while its buildings were being erected. Simultaneously, the Queensboro Bridge opened in 1909, followed in the next few years by the #7 Flushing Line, which brought 4 stations to Jackson Heights. Although the area was so desolate at the time, New York City mayor William Gaynor thought the subway a waste of resources, calling it the "cornfield line." While the architecture may look somewhat indistinct, the population is one of the most diverse in the city, home to Indians, Pakistanis, Bagladeshis, Bolivians, Peruvians and Colombians.

Previous spread:
page 206 (clockwise from upper left): Typical apartment blocks with setback gardens; Bar 75 Neon sign along Roosevelt Avenue; Ittadi Bazaar offers a great selection of South Asian foods on 73rd Street
page 207: The eight buildings that comprise the Towers were built in 1925 by Andrew J. Thomas and have some of the largest apartments in the neighborhood

This spread:
this page (clockwise from upper left): Men's Nehru Wedding Jacket on display at Karishma on 74th Street; apartment building gate ornament of griffon; apartment entry with stork medallion
opposite: Subway riders descend from 74th Street Broadway/Roosevelt Avenue Station

LONG ISLAND CITY

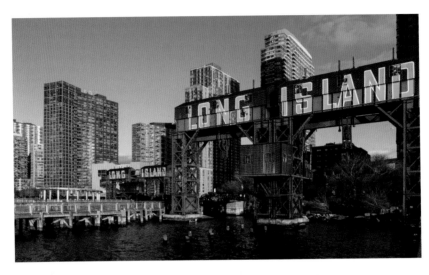

Formally known as Hunters Point, this land on the western edge of Queens, hard by the East River, was named for the English sea captain George Hunter, who purchased the land at some point from the Dutch. Various Europeans used the area for farming until the mid-nineteenth century. In 1861, the Long Island Railroad built a train terminus that initiated considerable industrial development. Since 2001 (when it was rezoned for dense residential development), Long Island City would have to be considered the fastest growing neighborhood in all of New York (neck and neck with downtown Brooklyn). Today's skyline is so chock-a-block with glass apartment towers that it seems to be a mirror of the Midtown skyline across the river. Between 2010 and 2017, 41 new residential buildings were

constructed, and judging from the amount of cranes that still dot the skyline, many more are still to come. LIC is truly at a crossroads—with a NYC ferry stop, several subway lines and both the Queensborough Bridge and Midtown Tunnel passing through its streets. Along the river is new parkland accessible to the entire community. There are soccer fields, a dog run, basketball, and walking paths all set against the dramatic views of Manhattan, the giant landmarked Pepsi Cola sign and old industrial gantries. Many of the former factories have been repurposed, the old Silvercup Bakery with its iconic sign looking down on the bridge is now a film studio, Jet Blue has moved its corporate headquarters into an old loft building, and the former Eagle Electric Company (the last factory to operate in Queens) will soon be living lofts.

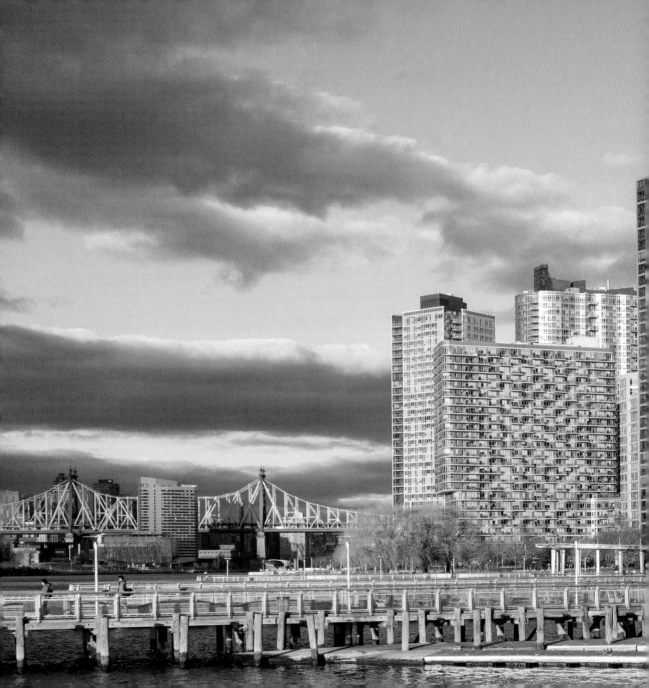

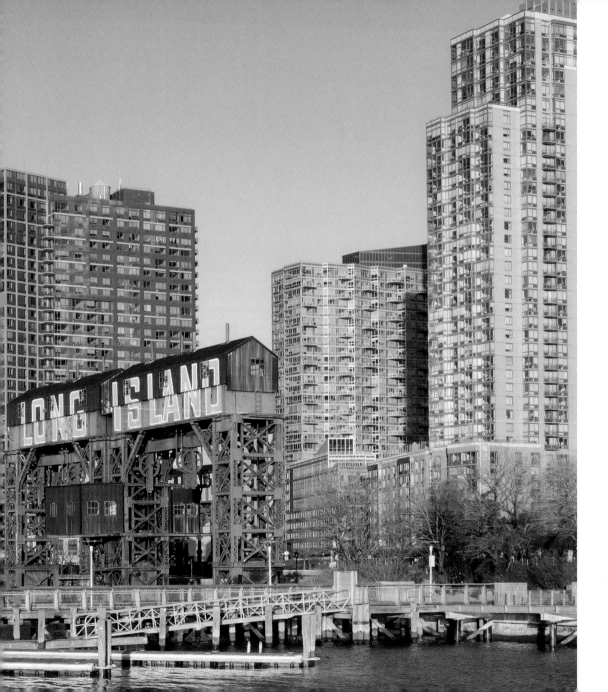

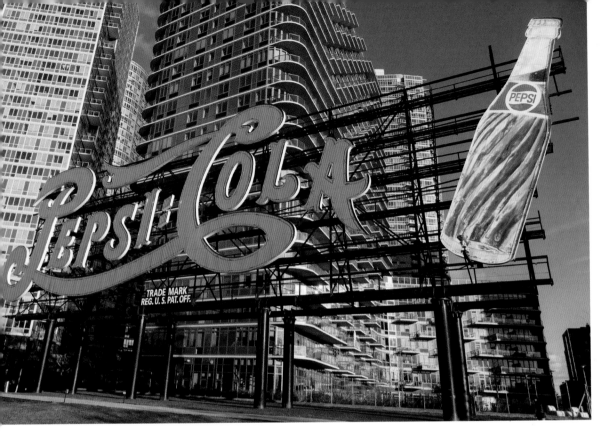

Previous spread (on pages 210-211):
page 210: The once abandoned, now refurbished gantries stand vigil at the edge of the East River Gantry State Park as a reminder to the industrial past
page 211 (clockwise from upper left): Steinway Storage Warehouse; biking under the Queensboro Bridge exit ramp, Silvercup Studios in background; basketball along the waterfront; marathon runners, crossing the Queensboro Bridge

This spread:
this page (top to bottom): The curlicue-lettered Pepsi Cola sign was first erected in 1940 and became an official NYC landmark in 2016; a family visits MoMA/PS1—the museum was built from an abandoned elementary school in 1971, and is known for presenting experimental art works
opposite: Skateboarding in Gantry State Park

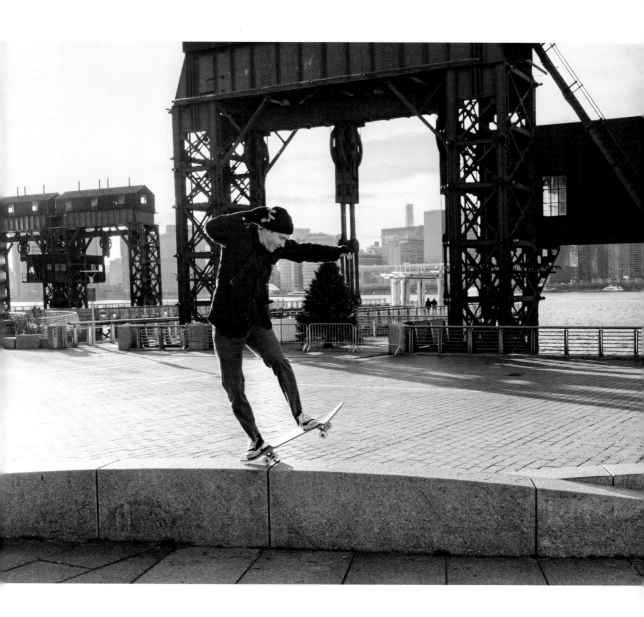

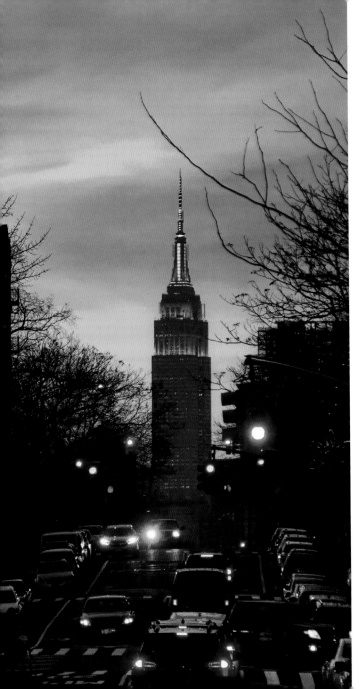
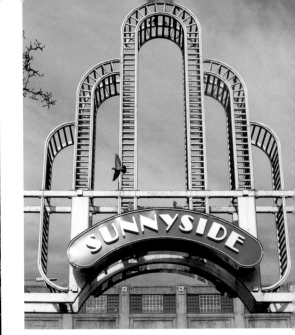

SUNNYSIDE

Once identified as "Sunnyside Hill," French Hugenots purchased the land and settled in the area in 1713. By the nineteenth century, it was known for its duck farms because the swampland made it ideal for keeping fowl. Hunters exploited the nearby forests to stalk edible prey. Sunnyside remained a quiet farming area until the erecting of the Queensborough (now Ed Koch) Bridge in 1909 and the building of the IRT #7 Flushing Line, whose concrete trestles that support the tracks run through the center of the neighborhood. Many squat new apartment buildings quickly filled in the farmland, and fleeing the slums of the Lower East Side, Manhattanites filled the apartments. "Sunnyside Gardens," located within Sunnyside, is a smaller community of mostly one-family gabled brick homes built from 1924 to 1928. Most of the homes are centered around verdant gardens, reminiscent of an English village. The neighborhood residential makeup is a polyglot, home to Bangladeshis, Indians, Armenians, Romanians, Chinese, Koreans, Colombians, and Ecuadorans, all attracted to the quiet and secure streets and convenience to Midtown Manhattan. The Gardens were called "the maternity ward of Greenwich Village" in the 1940s because of the many artists and writers and their children that were moving there. There is a striking contrast between the low-rise, six story brick apartment buildings of Sunnyside to that of the dense clusters of glass residential high-rises in Long Island City, facing off on either side of the elevated #7 train trestle.

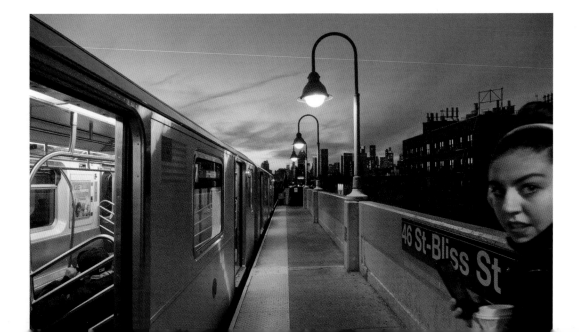

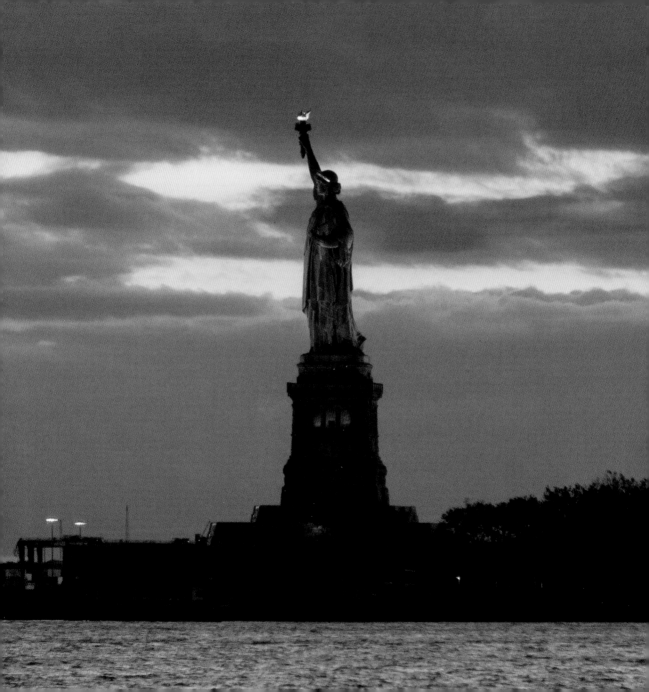

[STATEN ISLAND & NYC HARBOR]

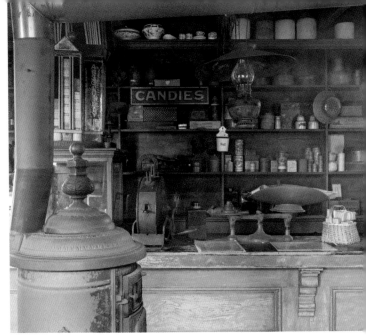

OLD RICHMOND TOWN

In 1728, Richmond Town became the original county seat of Staten Island. When Staten Island was incorporated into New York City 1898, the county government moved to St. George and Richmond Town became a sleepy backwater in the middle of what was very distant, rural farmland. The Staten Island Historical Society and the city of New York founded today's re-created village in 1958, with a collection of thirty, late-seventeenth- century to early-twentieth-century structures, all relocated to the site by the city. It is also home to the oldest continuously operating farm in New York City, and an original home from 1660. "Historic Richmond Town" was intended "not to freeze a single moment in time, but to create a journey through time." During the spring, summer and autumn, Richmond Town comes alive, period reenactors run the blacksmith shop, a nineteenth-century general store is stocked with dry goods, a working carpenter's shop cuts timber, and a 1920s ice cream shop serves (fresh and modern) ice cream. A highlight among the structures is the Voorlezer's House, a tiny seventeenth-century wood clapboard house that was a Dutch Reformed church and school until 1701.

SHORE ACRES / FORT WADSWORTH

Dutchman David Pieterszen de Vries first fortified the site of today's Fort Wadsworth in 1636 as a blockhouse. Because of its strategic location overlooking the Narrows into New York Harbor, the British built fortifications in 1779, and controlled them throughout the Revolutionary War. After losing the war, the Brits surrendered the territory to New York State, which built four new masonry fortifications,

including Forts Tompkins, Richmond, Morton and Hudson. The U. S. Army and the New York State Militia both used these forts to guard the Narrows during the war of 1812. Fort Richmond, constructed of granite, was renamed Battery Weed in 1902, and is occasionally open for tours. When the Fort Wadsworth complex was retired in 1994, it was the longest continuously operating garrisoned military base in United States history. The property was turned over to the National Park Service and became part of the Gateway National Recreation Area in 1995.

The contiguous Shore Acres neighborhood also offers spectacular views of New York Harbor. It is a mix of single-family homes, apartment buildings and industrial structures. Central to the area is "Cold Comfort," originally a one room Dutch farmhouse built in 1690 that became the Alice Austen House. Set right on the water, the house was enlarged into a Gothic Revival cottage and purchased in 1844 by Alice's grandfather. Alice and her mother lived there in the 1860s, after being abandoned by Alice's father. Alice established a photography business working out of the house and was joined by her lover Gertrude Tate in 1917. Unfortunately, due to financial hardship, they were forced to move in 1945, at which point the house fell into disrepair. Thankfully, Historic Richmond Town was able to secure her photographic archive, which it still maintains today. In the 1960s, a group of devoted neighbors got together to preserve and obtain landmark certification for the house and grounds. The city allocated $1.05 million for the renovation, which used Alice's own photographs of the interiors for authentication, today the house is decorated as it might have looked when Alice Austen lived and worked there.

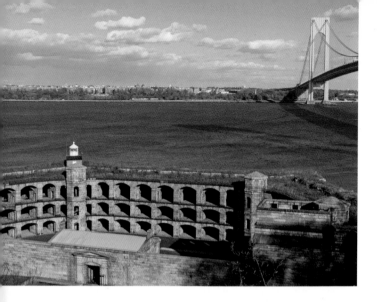

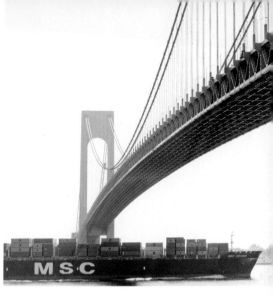

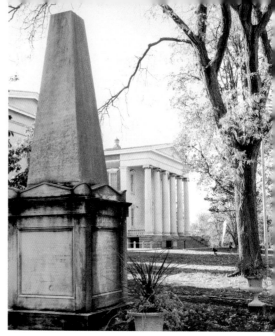

SNUG HARBOR / RANDALL MANOR

Located along the Kill Van Kull on the northern shore of Staten Island, down the road from working tugboat yards, is the 83-acre park called Sailors Snug Harbor, Cultural Center and Botanical Garden. Offering a window into New York's nineteenth-century maritime history, the grounds are filled with important architectural structures that were once residences for aged and retired sailors. Among the 26 buildings, one finds splendid examples of Greek revival, Italianate and Victorian styles. Many buildings have been repurposed into an assortment of non-profit art spaces, including the Staten Island Museum, the Newhouse Center for Contemporary Art, the Staten Island Children's Museum and the Staten Island Botanical Garden. Snug Harbor was founded by the bequest of shipmaster and Revolutionary War soldier Robert Richard Randall, who left his huge estate adjacent to Washington Square Park for the care of the seaman. However,

because legal challenges by his heirs spanned decades, the land around Randall's estate in Manhattan became so developed (and valuable), that it was sold for the proceeds to build a new Snug Harbor in Staten Island. Finally opened to seamen in 1833, Snug Harbor was governed from 1867 to 1884 by retired ship captain Thomas Melville, (brother of Herman). By the end of the 1800s, it was sheltering over 1,000 retired sailors, but by the 1950s, with the advent of Social Security, the resident number dropped to less than 200. The facilities fell into disrepair and the trustees proposed maximizing profit by building high-rise apartment buildings on the site in order to monetize the glorious views of the New York Harbor. Made aware of its historical importance by local preservationists, the Landmarks Preservation Commission and the city stepped in to make sure the site was declared a landmark, which it remains today.

STAPLETON HEIGHTS

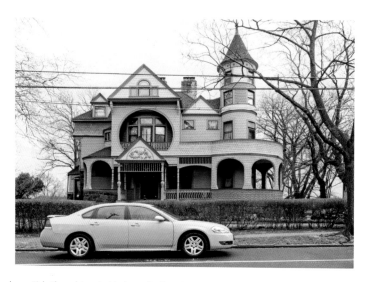

above: Pink Chevrolet parked in front of yellow Queen Anne Victorian home on St. Paul's Avenue
opposite (clockwise from top): Gargoyle on Trinity Lutheran Church; mural on the Sri Lankan
Lakruwana Restaurant; Art Deco Paramount Theater marquee on Bay Street

Running a few blocks along Bay Street, Stapleton constitutes a compact commercial area. Anchored by the colorful Sri Lankan restaurant Lakruwana, there are also a few small storefront churches, cell phone shops and the once grand, Deco style Staten Island Paramount Theater, that now operates as an event space. If one ventures up the hill for about a half mile, large homes once home to beer barons and ship captains can be seen in the St. Paul's Avenue-Stapleton Heights Historic District. Bordering the street are Victorians, Italianate, Arts and Crafts and Colonials, some dating to the mid-nineteenth century. The large yellow Victorian with a rounded porch and turret belonged to brewery baron George Bechtel. Stapleton became a center for beer production because of the many underground springs that provided ample supplies of water and caves for refrigerated storage. Among the beer producers were Bachman's Brewery opened in 1851 and Bechtel Brewery, founded in 1853. Rubsam and Horrman's Atlantic Brewery began operation in 1870 and was later bought by Piel's. Also known as R&H Beer, the quality may have been suspect, as it was sometimes referred to as "Rotten and Horrible." Yet it was the only brewery in the area to survive after Prohibition, it finally closed in 1963, marking the end of Staten Island's beer industry.

NYC HARBOR

As one of the largest protected natural harbors in the world, New York Harbor links the mighty Hudson River, the East River tidal estuary, and Newark Harbor to the Atlantic Ocean. Prime Lenape fishing and hunting grounds for perhaps millennia, New York Harbor began its exponential development when, in 1609, Henry Hudson first sailed into the majestic portal from the sea, searching for the Northwest Passage to Asia for the Dutch India Company.

Hudson could not have possibly imagined that his discovery would become one of the great trading and commercial ports in the entire world. The numerous rivers and bays with easy and protected access to the ocean, made the harbor ideal for shipping and trade. Governors Island became the site of the first permanent European settlement in 1624, with Brooklyn following in 1632.

In the mid-seventeenth century at the southern foot of Manhattan, the Dutch began building fortifications, streets and structures for housing and commerce. Docks were built along the river edges of the Hudson and East rivers. With the completion of the Erie Canal in 1825 (which connected the upper Hudson River to the Great lakes), New York became the busiest port in the United States, transporting goods between Europe, the heartland of the United States and the entire East Coast.

Because of the ports lining miles of waterfront, New York Harbor became a magnet for jobs and immigrants. A main port of entry built on Ellis Island became the demarcation point for twelve million new arrivals from 1892–1954.

With the advent of air travel and trucking, the need for shipping goods and people decreased by the mid-twentieth century, and many ports and docks became disused and neglected, with numerous waterfront neighborhoods becoming desolate and undesirable.

As shipping decreased, the waters became cleaner. The past fifty years has brought major transformation to the waterways surrounding New York, with vast networks of waterfront parks, ferry service and numerous high rise apartment buildings featuring water access and views, becoming some of the most coveted places to reside in the entire city.

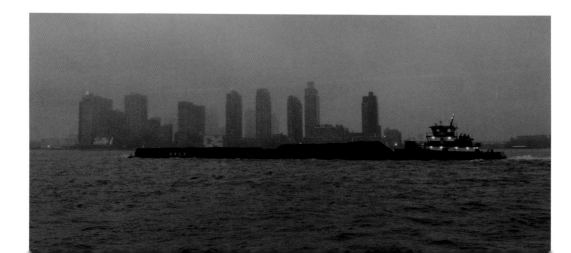

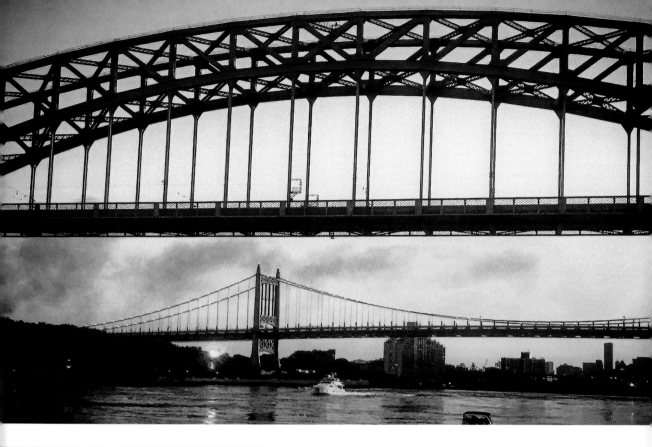

Previous spread:
page 228: Tug pushes coal barges up the East River at dawn
page 229 (clockwise from top): East River, Hell's Gate and Triborough bridges; cargo ship, downtown Manhattan skyline in background; abandoned tug off Staten Island

right: Staten Island Ferry heading into Battery Maritime Building, Slip 5 in lower Manhattan

First published in the United States of America in 2022
by UNIVERSE PUBLISHING
a division of RIZZOLI INTERNATIONAL PUBLICATIONS, INC.
300 Park Avenue South, New York, NY 10010
www.rizzoliusa.com

© 2022 Universe Publications, Inc.
Text and Photography © 2022 Andrew Garn

Publisher: Charles Miers
Editor: Douglas Curran
Production Manager: Colin Hough Trapp
Managing Editor: Lynn Scrabis

Designed by Aldo Sampieri

Printed and bound in China

2022 2023 2024 2025 2026/ 10 9 8 7 6 5 4 3 2 1

ISBN-13: 978-0-7893-3955-3
Library of Congress Control Number: 2021947984

Visit us online:
Facebook.com/RizzoliNewYork
Twitter: @Rizzoli_Books
Instagram.com/RizzoliBooks
Pinterest.com/RizzoliBooks
Youtube.com/user/RizzoliNY
Issuu.com/Rizzoli